T5-AAP-083

Gunter Lothert/Peter K. Burian
Canon Speedlite 540EZ

Magic Lantern Guides

Canon
Speedlite
540EZ

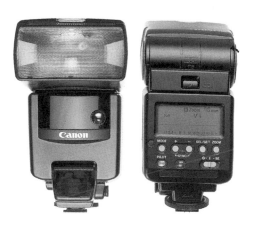

Gunter Lothert/Peter K. Burian

Magic Lantern Guide to
Canon Speedlite 540EZ

A Laterna magica® book

First English Language Edition 1996
Published in the United States of America by

Silver Pixel Press®
Division of
The Saunders Group
21 Jet View Drive
Rochester, NY 14624

From the German edition by Gunter Lothert
Edited by Peter K. Burian
Translated by Hayley Ohlig
Printed in Germany by Kösel GmbH, Kempten

ISBN 1-883403-30-8

®Laterna magica is a registered trademark of
Verlag Laterna magica GmbH & Co. KG, Munich, Germany
under license to The Saunders Group, Rochester, NY U.S.A.

*This book is not sponsored by Canon, Inc. Information, data, and procedures
are correct to the best of the publisher's knowledge; all other liability is
expressly disclaimed. Because specifications may be changed by the manu-
facturer without notice, the contents of this book may not necessarily agree
with changes made after publication. Photography is by Gunter Lothert, unless
otherwise noted. Product photos and diagrams were provided by Canon
GmbH. We would like to thank Chuck Westfall of Canon U.S.A., Inc., Camera
Division, for offering his technical expertise to this book.*

Contents

Understanding Flash Photography

A Brief History

Today's multi-mode SLR cameras, like the Canon EOS series, are highly capable but not fully effective without an electronic flash unit. Our goals in this guide are to cover the Canon Speedlite system by focusing on some of Canon's more popular flash units, and to help photographers of all levels exploit the many picture-taking opportunities an accessory flash unit offers. No matter how automated the flash and camera are, a few tricks of the trade are helpful in realizing the full potential of this creative tool.

Early Flash

In order to fully appreciate the value of electronic flash in photography, consider some of the history and development of this art and science. The first permanent image recorded with a camera was taken by the Frenchman Joseph Nicéphore Niépce in 1826 (though some evidence suggests that he achieved this even earlier). This photograph required eight hours of exposure from start to finish. Today, exposures can be made in a split second with the help of extremely sensitive films and cameras offering shutter speeds as fast as 1/4000 second.

Photographers longed to be independent of the restrictions of shooting in daylight from the start. Electric arc lights served to illuminate sitters in the studio, but the subjects had to remain still for the length of the exposure, which could last ten minutes or more. Freezing action and being able to shoot in dark locations outside the studio setting became possible only with the advent of portable flash. The first flash powders were made with a mixture of magnesium and calcium chlorate or potassium chlorate. Various methods of ignition were developed to make the use of flash powder relatively safe, but it was dangerous nonetheless, and accidents still occurred from time to time.

The Development of Electronic Flash

Flash photography became safer and more accessible with the introduction of vacuum flash tubes in 1925 (not commercially

available until 1929). These were glass tubes similar to light bulbs filled with aluminum foil or wire composed of magnesium and aluminum. Over time, they developed into flash cubes, which remained very popular for many years.

Electronic flash photography as we know it today began with a gas discharge tube designed in the United States in the 1930s by Dr. Harold E. Edgerton. This electronic lamp created a flash of enormous intensity and extremely short duration (up to 1/1,000,000 second), which could be fired at virtually any frequency and at any time. He used his invention to create a stroboscopic lighting effect, which made the action of rapidly moving objects—machinery, animals, bullets, and balloons—appear to freeze at selected intervals. This technology was applied to photography to preserve those moments on film. The resulting images were used to study the physics of motion, much the way Eadweard Muybridge's were in the 1870s.

In 1940 Eastman Kodak Company introduced what was to be the first commercially successful electronic flash unit. The brilliant burst of light was produced by a high-voltage charge passing through a tube filled with krypton, xenon, or a mixture of the two gases. After the Second World War, other companies started manufacturing similar units, boasting a flash duration between 1/500 second and 1/10,000 second. Photographs could now be taken even in total darkness, and all subject motion—even a hummingbird's wings—could be "frozen."

By the 1950s flash could be synchronized with the camera's shutter, firing at precisely the moment when the shutter uncovered the entire frame of film. Most flash units included a thyristor, which cut off the power after the exposure was made, saving the remaining power for the next photo in order to extend battery life.

Basic Principles of Flash Photography

Light Energy and the Inverse Square Law
Three factors influence the outcome of a flash exposure: the amount of light energy emitted by the flash (which is determined by the flash's output and its duration), the distance the energy has to travel to meet the subject, and the amount of light energy that actually strikes the subject.

Almost all light sources emit light at a specific angle, or cone, of illumination. The area covered by this cone of light increases as the light travels away from its source. This means that the same brightness is distributed over a progressively larger area the farther it travels. Because of this, an object will receive progressively less illumination as its distance from the light source increases. This may help explain how the Inverse Square Law applies to light emitted by a flash unit. This law of physics states that *brightness decreases in proportion to the square of the distance the light has traveled.* Put another way, doubling the amount of light does not double the shooting range, but increases it by less than 1-1/2 times. Therefore, if the flash provides correct exposure for a subject 10 feet (3 meters) away with the camera's lens set at an aperture of f/5.6, doubling the light by opening the lens one full stop to f/4 will provide correct exposure only as far as 14 feet (4.3 meters), not 20 feet (6 meters) away. Opening the aperture one stop allows twice as much light to pass, but an equivalent amount of flash will reach only 1.4 times as far.

Guide Numbers

The guide number is a value that quantifies the relationship between brightness, distance, and ISO film sensitivity in flash photography. It has been defined as the flash-to-subject distance multiplied by the aperture required at that distance to produce a good exposure with a given film (or, Guide Number = Distance x Aperture). ISO 100 film is usually the standard used. With today's sophisticated automatic flash equipment such as the Canon Speedlites, performing guide number computations is usually unnecessary. However, it is important to understand basic flash principles for use in situations in which adjustments to the flash output are required. Even when using a camera with Through-the-Lens (TTL) flash metering, adjustments to the flash exposure may be required occasionally.

Guide numbers are designed to make it easy for the photographer to calculate the lens aperture needed for a flash exposure, and therefore guide numbers follow a logarithmic progression comparable to f/stops, but in reverse. (A numerically larger guide number means more light, whereas a numerically larger f/stop means less light.) For example, if you know the distance from the subject and the guide number corresponding to the film sensitivity, then the required aperture can easily be determined. This

answers the question of what aperture to select in order to obtain the correct exposure for a subject at a given distance (Aperture = Guide Number ÷ Distance).

Note: Since distance is part of the guide number formula, guide numbers are calculated in terms of feet or meters. In the United States, a flash unit's guide number rating is expressed in feet and is consequently 3.3 times larger than its corresponding metric guide number.

Flash Synchronization

For good results, the electronic flash must fire when the EOS camera's focal plane shutter is completely open. A focal plane shutter consists of two curtains that move in sequence across the film. The first curtain opens, uncovering the film for exposure, and then the second curtain closes, providing a light-tight cover over the film again. Both curtains move at a constant speed in most shutter designs. Exposure time is changed by increasing or decreasing the amount of time before the second curtain is released. The synchronization speed (or sync speed) is critical because the flash must fire when the shutter is fully open or when the first curtain has completely uncovered the film and the second has not yet begun to close. The EOS camera, when used with a Canon Speedlite, automatically sets the correct shutter (sync) speed for the flash exposure. This prevents the camera from recording partially exposed frames due to the photographer setting a shutter speed that is too fast. It helps make the entire process far simpler than ever before, reducing the possibility of photographer error.

Sync Speed and Exposure

The short duration of electronic flash results in sharper handheld pictures and also freezes the subject's motion on film. It is not the camera's shutter speed but the duration of the flash that determines the exposure time for a photo lit entirely by flash. Therefore, when photographing in a darkened room, it makes no difference what shutter speed is used as long as flash synchronization is maintained.

The situation is different when photographing outside in daylight. The more ambient light there is, the greater its effect on the total exposure. When using flash in a situation in which there is a

The strong, yet lightweight blades of the focal plane shutter allow for extremely fast shutter speeds (up to 1/8000 second!).

significant amount of ambient light, selecting a slower shutter speed allows a greater amount of exposure by the existing light. However, to prevent overexposure or motion blur due to the ambient light, it is best to use the fastest possible shutter speed. A good rule to remember in these situations is that while the aperture controls the flash exposure, the shutter speed controls the ambient light exposure.

Slow Synchronization

Slow sync flash is a technique that combines flash and ambient light to adequately expose both the subject and its background in a dark environment or at night. It is advisable to use a tripod during a long exposure in order to avoid recording blur due to camera shake.

Second-Curtain Synchronization

With normal synchronization, the flash is fired at the beginning of the exposure, the moment after the first shutter curtain opens. The rest of the exposure is made by ambient light after the flash has fired, causing motion blur to appear *in front of* any moving object. With second-curtain sync (also known as rear-curtain sync) however, the flash is triggered at the end of the exposure, just before the second curtain begins to close and after the ambient light exposure has been registered on film. In this case, the motion blur

appears to *follow* the moving object. When using flash, this natural-looking motion blur is possible only when using second-curtain sync.

Flash Automation

Early Automatic Flash
The first real step in flash automation was the introduction of the so-called "autoflash" equipped with a photoelectric cell or sensor that reads the light reflected from the subject. When the sensor determines that exposure is adequate, the flash is switched off. This type of automation results in reasonably well-exposed images within a certain distance range and under standard conditions. However, it does not compensate for the coverage of different lens focal lengths, ambient lighting conditions, or lens attachments such as filters. Even so, when this type of automation was introduced, automatic "sensor" flash units were regarded as a giant step forward. Some of today's aftermarket flash units still operate on this principle.

Through-the-Lens (TTL) Flash Metering
By the 1980s, sophisticated TTL or "Through-the-Lens" flash metering systems became common. While TTL systems vary from brand to brand, the basic concept is similar. When the shutter opens, the flash fires and light reflected off the subject exposes the film. A sensor inside the camera, near the film plane, measures the light during the flash exposure. Once the computer determines that adequate light has been received for a correct exposure, the flash is automatically switched off. Because light is measured through the lens, the system is far more accurate than external sensors. The system "sees" the light striking the film and automatically adjusts for various lenses, ambient lighting conditions, or filters and accessories. The guide number, film speed, aperture, and subject distance are still important considerations, but calculations are made by the computer. As long as the subject is not beyond the range of the flash at the set aperture, an accurate exposure can be obtained. This allows the photographer to select the aperture that best meets his or her needs and produces the desired depth of field: a wide aperture (perhaps f/4) creates a narrow zone of

sharpness, and a small aperture (perhaps f/16) creates a more extensive one. The EOS camera's computer delivers the correct exposure by automatically setting the suitable sync speed for the selected aperture. As we'll see later in this guide, this is not always possible in some camera operating modes (for instance, a distant subject shot at f/22 with ISO 25 film in Program mode). That's because light decreases in intensity the farther it must travel. In that case, advanced warning (to set a larger aperture or move closer) is provided, however this will be discussed later.

Today's TTL flash systems have evolved into being an integrated partner that works in harmony with the camera through exchanging information and commands. Many EOS cameras feature built-in "pop-up" flashes, although their power output and versatility tend to be low. When greater distance range is required, one of the accessory Speedlites can be mounted on the camera, where it communicates flawlessly with the exposure computer. Either type takes the guesswork out of flash photography thanks to the "intelligent" circuits incorporated by Canon.

Canon Speedlite Flash Basics

Canon offers a wide range of Speedlite flash units, and each is compatible with the entire EOS camera line. Deciding which one to choose will depend on the unit's price, size, power output, and features. However, even Canon's high-power accessory Speedlites are reasonably small, lightweight, and easy to operate.

This guide deals primarily with the Canon Speedlite 540EZ system. The compact 300EZ, the 380EX (with unique capabilities when used with the EOS Elan II/IIE [EOS 50/50E] cameras), and the Macro Ring Lite ML-3 are also discussed. The Speedlite 430EZ (which has some of the same features as the 540EZ) is mentioned when appropriate.

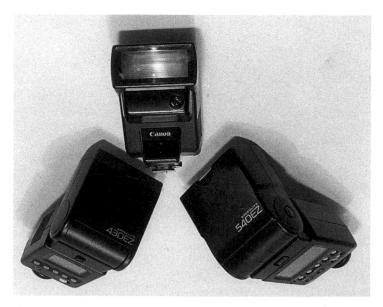

The Speedlite 300EZ, 540EZ, and 430EZ are just three Canon EOS system flash units. The multi-featured Speedlite 430EZ, has been replaced by the 540EZ, yet it still serves as an excellent backup or second flash unit. The Speedlite 300EZ (top) is a versatile flash unit for its compact size.

Each Speedlite has its advantages, but all share some common characteristics, especially TTL automatic exposure capability (called by Canon, TTL Automatic Flash Control). Aside from size and guide number, the controls, features, and overrides vary substantially among the many Speedlite models. The ML-3 is a specialized unit for use with EF Macro lenses, primarily for extreme close-up work. But no matter which Speedlite you choose, the EOS camera and flash will provide excellent results in a wide range of situations.

When Should Flash Be Used?

The most common use for flash is for indoor photography in dim conditions, when long shutter speeds would otherwise be required to adequately expose the film. Thanks to its short duration, a burst of flash can freeze motion, either camera shake or subject movement, to create a sharp image. Anyone who shoots portraits, fashion models, family parties, or groups involved in some activity would be hard-pressed to get along without an artificial light source.

Granted, a "fast" (highly sensitive) film of ISO 1000 or 1600 might be adequate in some cases to capture an image with ambient light alone. However the image will have more prominent grain and lower resolution. And, because a wide aperture (such as f/1.8) will still be required to obtain a fast shutter speed, depth of field will be extremely shallow, so parts of the image will appear blurred. Although these effects may be desirable in certain situations to create aesthetic impact, for the majority of photographs you'll prefer the effects produced by flash and a low ISO film—sharper, more colorful prints, a bright, clean look, and a more extensive range of sharp focus overall.

Throughout this guide we will discuss the use of flash as the primary or "key" source of illumination. Though some light may be entering through windows, we will presume that flash is the main light source for the exposure. We will also discuss fill flash, in which the extra burst of light is used to brighten or "fill in" an area of shadow on a sunny day, for example.

Color Temperature
The light from a Speedlite flash unit has a color temperature of

approximately 5500°K, which approximates that of daylight. Thus, when using flash, daylight-balanced film should be used. This also makes flash an excellent source of illumination for augmenting ambient light or for use in fill-flash photography.

Fill Flash

Automatic fill-in flash is easily achieved with a Speedlite and an EOS camera. This system mixes ambient light with flash illumination, making outdoor flash photography a breeze. When combined with the EOS metering system, the Speedlite's TTL flash metering system automatically moderates the amount of flash in bright conditions, producing a "natural" look while maintaining accurate background exposure. In overcast conditions, fill flash can add sparkle to an otherwise dull scene. It is often required on sunny days because of the extreme range of contrast—brilliant highlights and deep shadows. Often the tonal range is beyond the recording ability of the film—about three stops with slides and five with color print film.

Using flash is not mandatory outdoors, of course, but the exposures may be less satisfying if only ambient light is used. If the camera's exposure system meters for the highlights in extreme conditions, shadows will be rendered black, without any detail. And if it meters for the shadows, highlights will be completely washed out. By filling in shadows with flash we can bring them closer in value to the highlight areas, reducing the range of brightness to a level the film can record. With an EOS camera and a Speedlite, automatic "balanced" fill flash is available in some modes. The artificial light will not overpower the ambient light, so the overall look will be pleasing.

Indirect Flash

Although most people tend to use a single flash unit mounted on the camera's hot shoe or the one that's built in, the flat lighting that is produced can result in an artificial effect with little texture, depth, or dimension. Distinct shadows also tend to fall on the background, a less than pleasing addition to most photos. Speedlites that allow the flash head to be tilted upward or swiveled to the side allow for indirect flash, bouncing the light off a ceiling, wall, or reflector panel.

FP (High-Speed Sync) Flash

The Speedlite 380EX is able to synchronize with any shutter speed available on the EOS Elan II/IIE (EOS 50/50E) when set to FP (Focal Plane) or high-speed sync flash mode. This is especially useful when fill flash or catchlights are desired when shooting with ample ambient light or a large aperture.

Advantages of Fast Sync Speeds

Why would you want to use a fast sync speed?

The majority of EOS cameras produced to date offer a top sync speed of 1/125 second, while a few offer 1/250 second or 1/90 second. Although the Elan II/IIE's (EOS 50/50E's) normal top sync speed is only 1/125 second, when used with the Speedlite 380EX in FP flash mode, these cameras will allow for flash sync at any shutter speed. Indoors, a 1/125 second sync speed is adequate because flash provides the primary source of illumination. Outdoors however, where flash is most commonly used as fill lighting (with only a gentle burst), the higher sync speeds offer several advantages.

First, there is less risk of "ghosting" with a moving subject: image blur caused by the long ambient light exposure at 1/60 second with a second "frozen" image caused by the brief flash exposure. While this may be a desirable effect in some cases, most photographers prefer a single sharp image, possible at 1/250 second where the brief duration effectively "freezes" all but the fastest movement.

In addition, 1/250 second flash sync allows for the use of wider apertures (such as f/4 instead of f/8) useful in portrait photography to blur away a distracting background with shallow depth of field. In our experience, even a 1/250 second sync is adequately fast for most typical situations unless an ISO 400 or faster film is used on bright, sunny days. In that case, very small apertures (such as f/22) must be used to prevent overexposure, limiting the ability to control depth of field. The FP mode of the Speedlite 380EX used with the EOS Elan II/IIE (EOS 50/50E) allows for wider apertures to be selected—at higher sync speeds such as 1/1000 second. For more information, see the *380EX* chapter.

Off-Camera Flash

With the use of appropriate Canon accessories, the Speedlite flash

unit can be removed from the camera. Two or more Speedlites can be connected and fired simultaneously, producing portraits that look almost as if they were shot in the studio. Still lifes, flowers, close-ups, and macro photography all benefit from such advanced techniques, which produce a more professional effect. Full TTL automation is maintained for easy operation.

Stroboscopic Flash
Stroboscopic flash can be used to produce images depicting motion or abstract images. With the camera set to a slow shutter speed, the 540EZ can be set to fire many bursts of flash in rapid succession, recording multiple images of a subject in motion—a tennis ball, a golfer's swing, or a dancer's movement—on a single frame of film. See page 105 for more information.

Flash and Exposure

In this guide we assume that the photographer has some understanding of the concepts of exposure. If not, detailed explanations of exposure principles are offered in the *Magic Lantern Guides* to specific cameras. However, some suggestions regarding exposure will be provided here when necessary.

TTL flash metering can produce accurate results in most instances, however this cannot be true for every case, even with the advanced computers of the latest EOS cameras. All light meters are designed to produce perfect exposure with a midtone subject comparable to the 18% reflectance of a KODAK Gray Card. Hence, a white or black subject can still produce an underexposed or an overexposed image. In the same way, a boy playing by a bright ocean will be underexposed due to the high reflectance of the background, and a girl dancing in front of a black wall will be overexposed as the meter attempts to render the scene as an 18% midtone overall.

Ambient light and/or flash exposure compensation for unusually dark or bright situations is especially critical with slide film, because there is no printing stage involved at which exposure errors might be corrected. Those who use color print films of ISO 100 to 400 in particular may not need to worry as much about exposure accuracy. These films have a very wide

exposure latitude. Even if the negative is overexposed by up to three stops or underexposed up to two stops, good prints can often be made. This requires the photofinisher to compensate in the printmaking stage. If your prints are too dark (a common problem with some automated equipment), return them and request reprints.

Good results can be expected with an EOS camera and Canon Speedlite, except under the most difficult conditions. In this guide we will review the need for techniques, such as flash exposure compensation, that may be required in extreme cases.

Determining Whether Exposure Settings Are Adequate

When the shutter release is lightly depressed on any EOS camera, displays showing shutter speed and aperture appear in the viewfinder. If the exposure is likely to be correct, these values will not blink. Then, wait until the flash-ready symbol (a lightning bolt) appears before pressing the shutter release all the way down to make the exposure.

Once the exposure has been made, you can confirm that there was adequate flash exposure by checking the flash confirmation lamp on the 540EZ and 380EX Speedlite models, which should glow green for two seconds after the picture is taken. If it fails to light, try shooting the scene again, but move closer or use direct flash to assure sufficient flash exposure.

Guide Numbers

We discussed guide numbers briefly in the previous chapter, but a few additional comments are in order here. As a numerical measure of light output capacity, the guide number is particularly useful for comparing one Speedlite against another.

The appropriate shooting distance or lens aperture (f/stop) required for proper flash exposure can be calculated from the guide number formula: Guide Number = Distance x Aperture. The guide number itself—such as the 540EZ's guide number of 177 in feet—is NOT an indicator as to the actual maximum distance range of any flash unit. *Dividing the guide number by the aperture in use provides an indication as to actual flash range.*

When using the 540EZ, guide number calculations are never actually required. Even in Manual flash mode, the distance scale

on the back of the 540EZ confirms whether the flash-to-subject distance is within the flash range at any set aperture.

Using Faster or Slower Films in Flash Photography
Generally speaking, a fast film such as ISO 400 print film is perfect for flash photography in dark conditions indoors. Both color and black-and-white negative films of this speed offer excellent sharpness and minimal grain in an 8" x 10" enlargement.

The Speedlite 540EZ has a maximum guide number of 177 in feet (54 in meters) at ISO 100. But when ISO 400 film is used, the flash unit's guide number increases to approximately 347 in feet (106 in meters). Here's why.

When using a film other than ISO 100, a new, approximate guide number can be calculated by multiplying the old guide number by a factor of about 1.4 for each full increase in the level of film speed (i.e., ISO 100 to 200, 200 to 400, etc.), or dividing the old guide number by approximately 1.4 for each full decrease in the level of film speed (i.e., ISO 100 to 50, 50 to 25, etc.). Therefore, if an ISO 50 film is used, the guide number falls to about 128 (39 in meters). If an ISO 200 film is used, the guide number increases to about 248 in feet (76 in meters). With faster films it is possible to illuminate some large rooms even with bounce flash. However, films beyond ISO 1000 tend to be noticeably less sharp and have more grain. The table on page 109 shows values for other power levels that can be set manually from 1/2 to 1/16 power.

Guide Number Comparisons
Why bother with all these calculations if the Speedlite 540EZ does all the work itself and takes care of an accurate exposure? Basically, to gain an understanding of the relationship between film speed and effective range. If stopping down is required to obtain the desired depth of field, the guide number can never be too high. Effective flash range diminishes substantially as you shift apertures to f/16, f/22, and f/32.

Even with a very fast ISO 1600 film and a guide number of 680 in feet (208 in meters), the actual flash range is only 59 feet (18 meters) at f/11. Using a normal ISO 100 film and the highest possible guide number of 177 in feet (54 in meters) (with the zoom head at 105mm), the maximum flash range at f/4 is 43 feet (13 meters) and reduces to about 16 feet (5 meters) at f/11.

If a 24mm lens and the corresponding zoom head position is used, the guide number becomes 92 in feet (28 in meters); the maximum range at f/4 is 23 feet (7 meters) and reduces to a modest 8 feet (2.5 meters) at f/11. Consequently, unless you shoot frequently with ISO 400 or higher film in low light, a Speedlite with a high guide number will often be appreciated.

Compare the Speedlite 300EZ to the 540EZ. When the zoom head is set to 28mm, the compact flash 300EZ has a guide number of 72 in feet (22 in meters) at ISO 100. The Speedlite 540EZ offers a full 98 in feet (30 in meters) with the same setting. In practical terms, the 300EZ's maximum range at f/4 is 18 feet (5.5 meters) and a mere 6.6 feet (2 meters) at f/11. The 540EZ offers a full 24.6 feet (7.5 meters) and 9 feet (2.75 meters) under the same conditions.

Advanced amateur photographers and professionals typically shoot with lower ISO films for the highest resolution, color saturation, and sharpness, making the high output of the 540EZ valuable. Also, this is one of only two current Speedlites (at the time of this writing) that are designed to accept the remote battery packs, which reduce recycle times significantly (the 480EG is the other). Add to this the other features unique to this model, and the Speedlite 540EZ wins hands-down as the most useful flash Canon has ever produced for serious photography.

Guide Number Formulas

With ISO 100 film, the guide number of the 540EZ at full power is as follows:

❏ At 18mm zoom head setting with wide panel in place: 52 in feet, 16 in meters
❏ At 24mm zoom head setting: 92 in feet, 28 in meters
❏ At 35mm: 118 in feet, 36 in meters
❏ At 50mm: 138 in feet, 42 in meters
❏ At 70mm: 151 in feet, 46 in meters
❏ At 80mm: 164 in feet, 50 in meters
❏ At 105mm: 177 in feet, 54 in meters

The guide number of other Speedlites varies. With the 300EZ, for example, it ranges from 72 in feet (22 in meters) at the 28mm zoom head setting to 100 in feet (30 in meters) at the 70mm setting. With the 380 EX it ranges from 69 in feet (21 in meters) at the

24mm head position to 125 in feet (38 in meters) at the 105mm position (all at ISO 100).

This information can be used in Manual flash control mode with Speedlites other than the 540EZ or 430EZ, which do not include coupling range distance scales. The guide number will be required for calculating either the correct aperture for a subject at a certain distance or the correct camera-to-subject distance at any given aperture. The guide number can also be useful with the other Speedlites when exposure compensation is used to control ambient light (background) exposure.

The following examples assume you are using ISO 100 film and a Speedlite without a coupling range distance scale. Although we have used meters, the same approach can be used in feet:

Guide Number ÷ Aperture = Subject Distance

Example: With the 380EX set for the 105mm zoom head position the guide number of 125 divided by f/8 = approximately 15 feet. If f/8 is used, the subject should be no farther than 15 feet away from the camera.

Guide Number ÷ Subject Distance = Aperture

Example: Assume that your subject is 33 feet away. With the 300EZ at the 70mm zoom head position, the guide number of 98 (in feet) divided by 33 feet is about 3. You should use the nearest aperture of f/2.8 for an accurate flash exposure. If your lens does not have an aperture this wide, move closer to the subject—perhaps to 20 feet. Now the guide number of 98 divided by 20 equals about 5. The closest f/stop is f/4.5 on zoom lenses or f/4 on single focal length lenses. Use one of these aperture settings for an accurate flash exposure.

Other Flash Exposure Considerations

Automatic Flash Output Reduction
As we will discuss in more detail shortly, the level of flash illumination can be changed without affecting the exposure for the background. However, in both A-TTL (Advanced Through-the-Lens)

and TTL (standard Through-the-Lens) automatic flash modes, the EOS camera sets the ratio of flash exposure to background exposure automatically. In dark conditions the flash exposure is set to a standard level with any Speedlite.

As the level of existing light increases, a program built into EOS cameras progressively reduces the ratio of flash exposure to existing light exposure. This will vary depending on the brightness level of the scene to a maximum of minus 1-1/2 stops. *No indication is provided as to the amount of minus flash output reduction automatically input by the system.* However, this automatic ratio control provides a suitable amount of illumination for most fill-in flash situations.

The amount is often just right when shooting with color print (negative) film. With slides however—or in certain difficult exposure situations—you will want to manually increase or decrease the amount of flash exposure compensation based on experience. This technique is described in detail in the "Flash Exposure Compensation" section.

Standard TTL Automatic Flash Control
The concepts of TTL metering have already been described, but let's apply them to the Canon system. As mentioned previously, the light reflected from the film surface is measured by the camera's sensors during a flash exposure. When the amount of light corresponds to a proper exposure for the film speed, a control pulse is generated that stops the flash's discharge. The light value of the flash illumination reaching the film through the lens determines the exposure. Every EOS camera has one or more dedicated sensors aimed at the film plane for exactly this purpose.

Every Speedlite offers TTL metering, and though some offer A-TTL (Advanced Through-the-Lens) or E-TTL (Evaluative Through-the-Lens) metering as well, when used with any EOS camera, in some exposure modes the flash will default to using basic TTL flash metering. These modes include Aperture-Priority AE ("Av" for Aperture Value), Shutter-Priority AE ("Tv" for Time Value), and Manual ("M").

In Aperture-Priority AE or Shutter-Priority AE mode, the shutter speed (in Av) or aperture (in Tv) are set automatically by the camera after its metering system evaluates the scene. In Tv mode for instance, the shutter (sync) speed is set by the photographer (no

At the end of the day when the sun is low, using flash can help. Use a Speedlite 540EZ with an EOS camera to assure that both foreground and background are well exposed.

faster than the camera's fastest sync speed), and the aperture (f/stop) is set by the camera for the brightness level of the scene. In sunny conditions, a small aperture (perhaps f/16) is set, because little light is required to expose the film. Then when the shutter is released, the appropriate amount of flash is emitted—a minimal amount in this situation, just enough to brighten the primary subject before flash output is quenched. The background should be correctly exposed as well since the camera selected an aperture-shutter speed combination based on an evaluation of the ambient-light conditions.

In low-light situations the camera sets a wider aperture (perhaps f/4), since more light is required to expose the film. The Speedlite is the main light source, so a substantial amount of flash is fired before it is shut off. If the subject is within the range of the flash, it should be exposed correctly.

This gives you a basic sense of how TTL flash metering works in Shutter-Priority AE mode. For more information on TTL works with Aperture-Priority AE or Manual exposure mode, see the chapter *Using the 540EZ in A-TTL and TTL Mode.*

Note: A distant background may not be adequately exposed if it is beyond the range of the Speedlite in use. As we'll see later however, the system will attempt to render the surroundings brightly in the camera's Aperture-Priority AE mode. Even with flash, a slow shutter speed should be set in order to allow a dark background enough time to register on film.

A-TTL Automatic Flash Control
When Canon's EOS cameras are used with Speedlites 540EZ, 430EZ, and 300EZ, Advanced Through-the-Lens (A-TTL) automatic flash exposure mode can be selected. A-TTL is the default mode with these units when used in any of the cameras' Program modes (which include Program AE, Full Auto, or any of the Elan's Programmed Image Control or "PIC" modes). The term "Advanced" refers to the pre-exposure flash burst that is automatically emitted in this flash mode to measure subject distance before the shutter even opens.

The microprocessor of an EOS camera compares the aperture required for correct background exposure with the aperture required based on the flash-to-subject distance. Of these two aperture values, the smaller is chosen and correct exposure is achieved regardless of the lighting conditions. Naturally, this assumes that the subject is within the range of the Speedlite in use.

Another advantage of the A-TTL system is that it selects progressively smaller apertures in dark conditions as the flash-to-subject distance is reduced. Consequently, depth of field—the zone of apparent sharp focus—is often adequate to render a nearby subject sharply.

Whenever an EOS camera is set for a Program mode, A-TTL flash control is automatically activated on the 300EZ and should be set on the 540EZ Speedlite, as will be explained later. A-TTL flash control is equally successful indoors and outdoors in all lighting conditions. Both the shutter speed and aperture are selected automatically by the camera's microcomputer in Program or Full Auto modes.

Note: The Speedlite 540EZ's A-TTL pre-flash operates only in the EOS cameras' Program modes: Full Auto (available on some EOS models), standard Program, or one of the subject-specific PIC programmed modes (available on most EOS cameras). In other camera operating modes, conventional TTL flash control is employed without the pre-flash. We will discuss the advantages of A-TTL more specifically in later sections.

In low-light conditions when the flash is the main light source, the system will set a sync speed fast enough to allow for handheld photography without blur. In bright situations such as outdoors, the background is correctly exposed and the Speedlite emits the right amount of fill-in illumination. With A-TTL the surroundings are more accurately exposed than with TTL flash control because the metering computer has more information to work with—that is, the extra data provided by an analysis of the pre-flash.

Note: Whenever accurate background exposure is essential, we recommend the use of A-TTL flash in Program AE mode. In this mode, the photographer can control flash exposure, ambient light exposure, or both, depending on the combination of camera and flash in use. The photographer can control flash output either by setting flash exposure compensation on the 540EZ and 430EZ Speedlite when mounted to any EOS camera, or by using the flash exposure compensation control on an EOS-1N/1N RS, EOS A2/A2E (EOS 5), or an Elan II/IIE (EOS 50/50E) camera mounted with any Speedlite. If your EOS camera has an exposure compensation function, you can use it to control the ambient light exposure independent of the flash exposure for the subject.

E-TTL Automatic Flash Control

E-TTL (Evaluative TTL) flash is available only on the 380EX Speedlite when mounted to the Elan II/IIE (EOS 50/50E) (at the time of this writing). Rather than using the camera's multiple-zone metering system to meter flash exposure, the 380EX has the capacity to link up with the Elan II/IIE's AIM (Advanced Integrated Multi-Point Control) system, linking flash, metering, and autofocus readings. The camera's evaluative metering system is used to balance flash and ambient light exposure for more precise flash exposure control. See the chapter on the 380EX for more information.

TTL Flash with Camera Exposure Modes

When the EOS camera's built-in Speedlite is used, standard TTL flash control is employed with automatic flash output control. Because of its importance, we'll review briefly how this operates with an EOS camera and an accessory Speedlite. The issue of flash and ambient light exposure will be discussed in greater detail in subsequent chapters.

Aperture-Priority AF (Av) Camera Mode
Using the EOS camera's Av exposure mode and TTL flash, the photographer can control the depth of field by selecting the f/stop. For example, f/16 provides a wide range of apparent sharpness, while f/2.8 produces a shallow range, which serves to defocus a cluttered background. Set the desired aperture on your EOS camera using the appropriate dial.

The corresponding shutter speed is set by the camera automatically within its range of sync speeds, from 30 seconds to the camera's fastest sync speed. In bright light, the camera's aperture display blinks in the viewfinder as a warning if the photographer has selected an aperture that is too wide for the conditions at hand. To rectify this, dial in a smaller aperture (larger f/number) until the display stops blinking. In dim light, the camera may select a slow shutter speed in order to expose the background sufficiently. The brief burst from the Speedlite exposes the subject, and flash is shut off once this is adequate, however the ambient light exposure will continue after the flash exposure if the camera has selected a slow shutter speed.

Shutter-Priority AE (Tv) Camera Mode
In the camera's Tv mode with TTL flash control the "Time Value," or sync speed, is selected by the photographer using the camera's dial. Any shutter speed from 30 seconds up to the fastest sync speed available on the camera can be selected. The system responds with a corresponding aperture as determined by the camera's metering system.

This will attempt to correctly expose the background while the flash illuminates the subject. In dim conditions, the aperture value displayed in the viewfinder blinks to warn you if the shutter speed is too fast to sufficiently expose the background. Dial in a slower shutter speed until the aperture stops blinking. Release the shutter,

and once adequate flash exposure is detected, flash output is quenched.

Manual Exposure (M) Camera Mode

In the camera's Manual exposure mode the photographer sets both the aperture (f/stop) and shutter speed. With the 540EZ and 430EZ, you can check the usable flash-to-subject distance range for the aperture selected, unless bounce flash is being used. As long as the subject is within the range displayed on the Speedlite's LCD (Liquid Crystal Display) panel, it should be exposed properly.

Any shutter speed from 30 seconds to the camera's fastest sync speed can be selected. The exposure level scale on the camera's LCD and viewfinder displays will indicate correct or incorrect exposure settings for ambient light.

Note: The subject should be correctly exposed by TTL flash if it is within the range indicated by the coupling range distance scale on the back of the 540EZ or 430EZ. However, the surroundings may be excessively dark or bright, depending on the readings indicated on the camera's exposure level scale. Shift to a different f/stop or shutter speed until the exposure level scale indicates a "correct" setting.

The camera's Manual mode is used with flash primarily to produce creative effects or to control depth of field and the depiction of motion simultaneously. A moving car, for instance, can be blurred by a slow shutter speed, or frozen in time by a fast shutter speed. You can experiment with various shutter speed and aperture combinations to produce a variety of effects.

About the Canon Speedlite 540EZ

With the introduction of the professional EOS-1N camera in 1994, Canon released the 540EZ, a flash unit that is fully compatible with all EOS cameras. Although its predecessor, the Speedlite 430EZ, is very capable, the 540EZ offers several advantages.

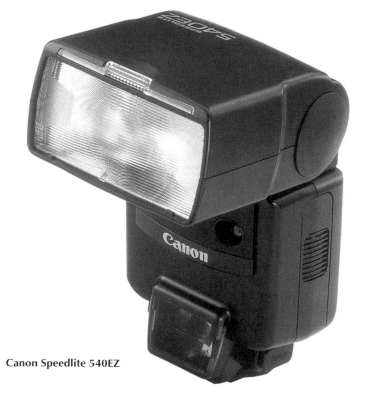

Canon Speedlite 540EZ

540EZ's Primary Enhancements

Improvements of the 540EZ over the Speedlite 430EZ include the following:

- ❏ Greater power output and extended zoom-head range
- ❏ Coverage for lenses as wide as 18mm with the built-in wide (diffuser) panel
- ❏ Improved reliability of flash exposure control
- ❏ Built-in AF auxiliary light corresponding to the EOS-1N and RS cameras' five focusing points
- ❏ More versatile operation in Stroboscopic ("MULTI") mode
- ❏ Eight manual power output levels from 1/1 (full) to 1/128 power – greater versatility than any other Canon Speedlite
- ❏ Larger LCD display panel for improved readability
- ❏ Automatic flash exposure confirmation LED illuminates after adequately exposed picture is taken in A-TTL or TTL mode
- ❏ Quick Firing now possible with an external power source
- ❏ Ability of flash head to be tilted downward
- ❏ Warmer color balance for more pleasing skin tones

As the name implies, the 540EZ offers a maximum guide number of 177 in feet (54 in meters) at ISO 100 and at the 105mm position of the zoom head. This is the most powerful of any shoe-mounted Speedlite in the Canon system, and has one of the highest guide numbers among flash units of this size in any brand. There are several advantages to the high guide number:

- ❏ Greater "reach" for distant subjects or when using bounce flash
- ❏ Extended range for fill flash
- ❏ Shorter recycle times in automatic modes in the short-to-intermediate distance range
- ❏ Because smaller apertures can be selected with a more powerful flash unit, the extra power available can be used to increase depth of field in close-up work.

This high-performance Speedlite is ideal for the professional or advanced amateur photographer as it includes by far the most features of any Speedlite. The head features an internal motorized zoom that can adjust flash coverage in seven steps from 24mm to 105mm. The head adjusts automatically to suit the focal length of the lens in use, ideal especially with Canon EF zoom lenses. The zoom mechanism can also be set manually to any desired position when a specific effect is required. A wide-angle diffuser panel

is built in. When you pull it into place over the flash tube, the head zooms automatically to its widest position. At this setting the light coverage matches the angle of view of a super wide-angle 18mm lens.

Full flash capability is offered. The head can be tilted upward, to either side (for bounce flash), and downward by 7° for extreme close-ups so the light is not projected above the subject. The 540EZ is ideal for such work as it can be placed closer to the subject than any other EZ-series Speedlite while maintaining good flash exposure.

Combined with an EOS camera, the 540EZ makes everything from simple automated flash to advanced flash techniques possible. Of all the features mentioned, the most notable is automatic flash exposure confirmation—a first for the EOS system of EZ-series Speedlites. After a flash picture is taken in TTL or A-TTL mode, an LED lamp on the back of the 540EZ glows for two seconds if there was adequate flash exposure. This is a welcome addition that prevents guesswork or shooting by trial and error.

The 540EZ's multi-firing stroboscopic function (MULTI, or Stroboscopic, mode) is also highly capable. It can be set to automatically fire several times during a single exposure to produce a strobe effect. The number of bursts (from 1 to 100) and the number of bursts per second (up to 100) can be pre-set. This mode can be employed to record several phases of a subject in action—such as a golf swing or tennis stroke—on a single frame of film.

Other 540EZ Features

Compatibility with Multi-Point Focus and Metering Sensors

Like the 430EZ, the 540EZ is fully compatible with the five-point autofocus sensor and three-point TTL flash metering of the EOS-1N and EOS-1N RS's flash metering functions. When used with an EOS camera with multiple focusing points (EOS-1N/RS, EOS-A2/A2E [5], Elan II [EOS 50] series, EOS-10S [10], EOS Rebel X/XS [500]), the 540EZ automatically biases its flash exposure to the subject in focus. Flash is optimized for the area of the frame where an AF sensor has set focus—the primary subject instead of some other element in the composition. This improves accuracy with off-center subjects, a feature especially valuable when shooting quickly.

Speedlite 540EZ

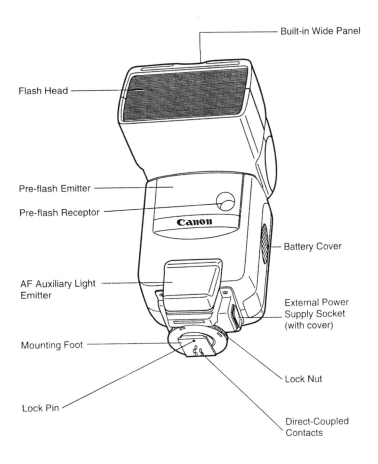

Built-in Wide Panel

Flash Head

Pre-flash Emitter

Pre-flash Receptor

Canon

Battery Cover

AF Auxiliary Light
Emitter

External Power
Supply Socket
(with cover)

Mounting Foot

Lock Nut

Lock Pin

Direct-Coupled
Contacts

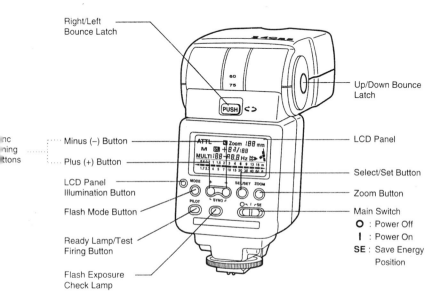

Right/Left Bounce Latch

Up/Down Bounce Latch

LCD Panel

nc
ning
ttons

Minus (–) Button

Plus (+) Button

LCD Panel Illumination Button

Flash Mode Button

Ready Lamp/Test Firing Button

Flash Exposure Check Lamp

Select/Set Button

Zoom Button

Main Switch

O : Power Off

I : Power On

SE : Save Energy Position

AF Auxiliary Light

With most EOS cameras, the 540EZ's built-in autofocus auxiliary light fires automatically in low-light situations, emitting a red pattern onto the subjects within its effective range of 1.7 to 49.5 feet (0.5 to 15 meters). This provides a more reliable target for the AF sensors for greater focusing speed and reliability. When this feature is used with the EOS-1N, the light emitted corresponds to the camera's five-point AF detection sensors. When the 540EZ is mounted to an EOS camera with a multi-point focusing system and a built-in flash, the camera's own AF auxiliary light operates instead.

Second-Curtain Sync

Selectable sync timing allows you to choose second-curtain sync, which fires the flash at the end of a long exposure. This creates realistic motion streaks that follow behind a moving subject instead of preceding it as is the case with conventional first-curtain flash sync photography and long shutter speeds.

A-TTL and TTL Flash Control

A-TTL (Advanced-TTL) automatic flash control and standard TTL automatic flash control both provide appropriate exposure for the subject while controlling the background exposure according to the shooting mode selected on the camera.

Flash Exposure Compensation

A flash exposure compensation feature is included on the flash unit to increase or decrease flash illumination. The level of compensation can be set +/− 3 stops in 1/3-stop increments on the 540EZ. Some EOS camera models have their own flash exposure compensation control (EOS-1N, EOS A2/A2E [5], or EOS Elan II [EOS 50] series), which can be set on the body instead, if desired.

Note: Flash exposure compensation settings on the 540EZ always take priority over flash exposure compensation settings on the body, except when the 540EZ's flash exposure compensation value is set to zero (0).

Save Energy Feature

The 540EZ has a Save Energy (SE) function, which conserves

battery power by shutting the flash down automatically after 90 seconds of non-use. Pressing the camera's shutter release button halfway or pressing the test firing button cause the Speedlite to reactivate, recycling quickly.

Using the 540EZ with Various EOS Camera Models

The Speedlite 540EZ is designed for use with EOS model cameras. At the time of this writing, the following models are currently in production. Some designations are different for models sold in North America than for those intended for sale in other countries. Designations for models sold outside North America are in parentheses.

EOS Rebel X and XS (EOS 500), EOS A2E (EOS 5), EOS-A2, EOS-1N and EOS-1N RS, and the EOS Elan II/IIE (EOS 50/50E).

 The following EOS cameras are no longer in production but are still in use by many photographers around the world. They can take advantage of most Speedlite 540EZ capabilities. Certain functions (noted) will not operate with some of the older models.

EOS 620, EOS 630 (EOS 600), and EOS 650; EOS 750 and EOS 850 (except stroboscopic flash and second-curtain sync); EOS-1, EOS 10S (EOS 10), EOS 700, EOS Rebel (EOS 1000), EOS Elan (EOS 100), and EOS Rebel II (EOS 1000N).

 All current and discontinued EOS models are fully compatible with the Speedlite 540EZ in A-TTL mode. The three-zone flash exposure metering operates only with the EOS-1N/1N RS, EOS 10S (EOS 10), EOS A2/A2E (EOS 5), and Rebel X/XS (EOS 500).

Note: Flash exposure compensation can be set on the EOS A2/A2E (EOS 5) or the EOS-1N/1N RS instead of the 540EZ, if desired, as long as the flash exposure compensation setting on the flash unit is set to zero (0).

EOS System Compatibility
The 540EZ adapts to whichever EOS camera is in use, taking advantage of the camera's capabilities (such as multi-point AF

sensors) to achieve the best possible results with flash exposure. A full range of accessories is available (such as the Off-Camera Shoe Cord 2) for remote flash operation without losing any of the flash unit's capabilities. As we'll see, other adapters and cords permit elaborate multiple-flash setups while maintaining full TTL flash metering controlled by the EOS system.

Note: When an accessory Speedlite is mounted to an EOS camera that includes a built-in flash, the built-in flash is disabled. Of current EOS models, only the EOS Rebel X, EOS-1N, and EOS-1N RS do not feature a pop-up flash head.

"User-Friendly" Operation

Because of the fully integrated system compatibility, mounting the 540EZ on any EOS SLR—or on one of the off-camera accessories—creates one functional entity. Each of the five contacts on the Speedlite's foot matches up with one of the five contacts on the camera's hot shoe. Tightening the flash's large, easily gripped lock nut is very easy. A spring-loaded locking pin on the foot of the flash ensures maximum security with EOS cameras that have a matching socket. The 540EZ can also be mounted securely to EOS cameras lacking the locking pin socket (such as the EOS 620, 650, 750, and 850).

The flash unit's control buttons are quite large but recessed to prevent inadvertent activation. Important settings such as flash exposure compensation can be locked in permanently. Turning both the camera and flash on opens the communication channel between the two units promoting full metering accuracy. Once they are turned on, the photographer can start shooting, for even the film speed set on the camera is transmitted automatically to the 540EZ Speedlite!

Data Display
Part of the 540EZ's user-friendliness is its clear information display, which shows all that is important to its operation. The LCD panel is 2.3 times larger than that of the earlier 430EZ, increasing readability. A built-in illuminator can be activated by the touch of a button (for 8 seconds) under low-light conditions.

540EZ LCD Panel

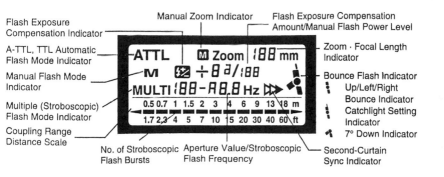

Flash Exposure Compensation Indicator

Manual Zoom Indicator

Flash Exposure Compensation Amount/Manual Flash Power Level

A-TTL, TTL Automatic Flash Mode Indicator

Manual Flash Mode Indicator

Multiple (Stroboscopic) Flash Mode Indicator

Coupling Range Distance Scale

No. of Stroboscopic Flash Bursts

Aperture Value/Stroboscopic Flash Frequency

Zoom · Focal Length Indicator

Bounce Flash Indicator
- Up/Left/Right Bounce Indicator
- Catchlight Setting Indicator
- 7° Down Indicator

Second-Curtain Sync Indicator

This panel displays a broad variety of information, depending on the mode selected. This includes indicators for A-TTL, TTL, or Manual firing mode, zoom head position, flash exposure compensation level, Strobe ("MULTI") flash mode, the number of bursts selected, effective distance range, f/stop in use, second-curtain sync, and more. This allows the photographer to quickly monitor all active settings.

41

Getting to Know the Speedlite 540EZ

The more functions a flash unit offers, the greater its versatility, and the more chances you have of getting superior results. However, increased features should not make a model too complicated to use, so facility and logic in its operation were the primary goals of Canon engineers when they designed the Speedlite 540EZ. While the photographer can allow the "intelligent" computer of the EOS camera to take over and produce standard flash effects automatically, the 540EZ should encourage creative photography as well. Let's start with the basics.

Power Options

The Speedlite 540EZ uses four AA alkaline-manganese batteries (LR6/AM-3), AA lithium (FR6) batteries, or rechargeable AA NiCd batteries (KR15/51). Although it will also accept four AA manganese batteries (R6/UM-3), these are not recommended due to their low power capacity.

Alkaline Batteries
The four alkaline AA batteries that usually power the Speedlite 540EZ are quite adequate for most applications. The chart on page 52 provides an estimate as to the number of bursts and the recycle times you can expect with a fresh set. For quicker recycle times or in cold temperatures, rechargeable NiCd AA batteries can be used; however their life is noticeably shorter in normal temperatures.

Lithium Batteries
Lithium batteries are unique in that they have a long shelf life, holding 90% of their charge after ten years in the package. These batteries offer about double the number of flash bursts in the 540EZ compared to alkalines, but they are more expensive. Lithium cells are a good choice when traveling on long trips or on special occasions when extended battery life is helpful. They are also an

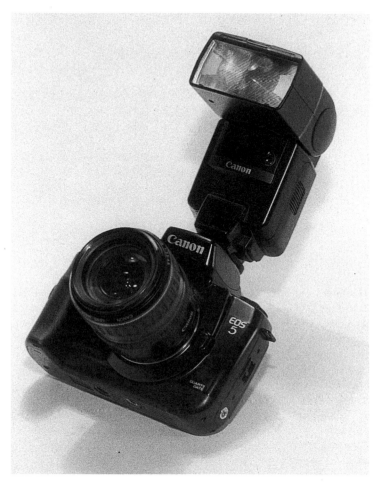

When mounted on any EOS camera, the versatile Speedlite 540EZ can handle almost any situation requiring flash.

excellent choice to store for emergencies as a back-up set in your camera bag due to their long shelf life. Also, because the lithium AAs are not universally available, if you decide that they fit well with your style of photography, you may want to buy several sets at a time.

However even the lithium AAs cannot handle extensive use, such as professional applications when near-instant recycling is required so as not to miss the next shot. The number of flashes per set is limited, and recycle times become longer as battery power diminishes.

Canon does not recommend the use of lithium AA batteries in any Speedlite except the 540EZ and the 380EX because of voltage irregularity. The 540EZ and 380EX are designed to compensate for this tendency, precluding the risk of damage. However, Eveready® offers to repair or replace any flash unit damaged by their lithium batteries (at least in North America). In other countries, or if other brands become available, check with your retailer as to the guarantee provided by the battery manufacturer.

Caution: Lithium AA cells are not recommended for use in the Compact Battery Pack E as they may damage the circuitry.

Rechargeable NiCds

Those who wish to avoid having to constantly buy batteries can use four NiCd (nickel cadmium) rechargeable AAs with the Speedlite 540EZ. We recommend buying two sets so that one can be charged while the other is in use. Chargers that fully drain the batteries before charging them again are best in order to avoid the loss of memory typical of NiCd batteries. Over time they can become unable to accept a full charge if they are repeatedly charged before all of their power is depleted.

Caution: Never attempt to recharge alkaline or other single-use batteries. Overheating, leakage, or worse, an explosion, may occur. Certain rechargeable alkaline batteries are now available, and they are clearly marked as such. Follow the instructions, and recharge them only in the charger that comes with the set.

NiCds provide quicker flash recycling times than alkaline batteries (see chart on page 52). They are also more resistant to temperatures that fall below the freezing point. In winter, carry a second set in a warm pocket; when the first becomes weak, switch sets. The weak set can be used later under warmer conditions.

Loading Batteries

To load the batteries, slide the compartment cover downward and then swing it out. Load the batteries with the poles aligned as indicated in the diagram inside the chamber. If you should make a mistake, the flash simply will not work until the batteries are loaded correctly. Close the battery compartment again by flipping it shut and sliding it up toward the top of the flash unit. When replacing batteries it is always a good idea to gently clean the battery contacts with a soft cloth or pencil eraser.

To open the battery compartment, slide the cover down and then swing it out toward the front of the flash. Install the batteries so that the terminals (+, −) match the diagrams inside the compartment. Close the compartment by swinging the door closed and pushing it up into its locked position.

Battery Care

The following suggestions will help you to get the maximum value from any type of battery:

❏ Always install four fresh, new batteries of the same kind (alkaline-manganese, NiCd, or lithium). Do not mix battery types! Never replace only two of the four as the weak batteries will quickly drain the new ones.

❏ When the Speedlite will not be used for more than 30 days, remove the batteries to prevent discharge and to avoid the risk of damage should a battery leak.

❏ The terminals on some AA NiCds are shaped differently than those on AA alkaline batteries. Make sure the batteries are suitable for use in your Speedlite flash before buying them.

❏ Dirty battery contacts can obstruct the flow of electricity. To prevent corrosion and dirt buildup, clean them gently with a pencil eraser and wipe the contacts with a clean cloth whenever you replace the battery set.

❏ Alkaline batteries can be stored for several years without losing more than 20% of their charge (most battery packages have a printed expiration date). Battery life can be extended by keeping them in a cool, dry place.

External Power Sources

Two external power sources are available for the Speedlite 540EZ: the Transistor Pack E with Battery Magazine TP, which holds six C-size alkaline batteries or the NiCd Pack TP. The smaller, Compact Battery Pack E requires six AA alkaline-manganese batteries (LR6/AM-3) or NiCd rechargeables.

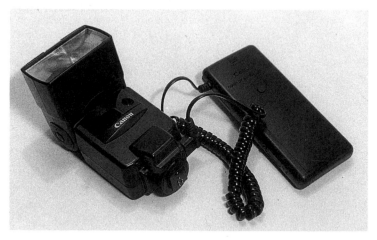

The Compact Battery Pack E can be attached to the Speedlite 540EZ and 430EZ. With six AA alkaline or rechargeable NiCd batteries, it offers extra energy that may be required in demanding shooting situations.

Note: Batteries must be loaded in the 540EZ's battery compartment when using an external pack in order to provide power for

the flash's circuitry and LCD display panel. Both the internal and external batteries are used simultaneously to charge the flash. Consequently, if the internal batteries are exhausted, the 540EZ will cease to operate. Always carry a spare set of AA batteries to avoid disappointment and frustration.

Mounting the Speedlite 540EZ

Mounting the 540EZ is simple, but follow this procedure carefully to avoid unnecessary problems.

1. Loosen the lock nut by turning it counterclockwise several times.
2. Slide the flash's foot into the camera's accessory hot shoe (slide it from the back of the camera towards the front) or into the shoe of an Off-Camera Shoe Cord 2; with the latter, make sure the contacts line up correctly (i.e., do not insert it backwards!).
3. Lock the flash foot to the shoe by turning the lock nut clockwise until it is snug. This will seat the flash unit's lock pin (protruding from the bottom of the foot) into a hole on the camera's hot shoe, securing the Speedlite firmly in place. Although lock pin holes are not provided on the EOS 620, 650, 750, and 850, the Speedlite 540EZ will still mount securely on these cameras.

 Caution: *Do not overtighten the lock nut. This can damage the threads and/or make removing the Speedlite difficult.*

4. To remove the Speedlite, turn the lock nut several times counterclockwise and slide the foot out of the camera's accessory shoe (sliding it towards the back of the camera).

The Main Switch

The Speedlite 540EZ's main switch is located near the lower right-hand corner of the LCD panel on the back of the unit. It has three user-selectable positions: "O" for off, "I" for on, and "SE" for activating the "Save Energy" feature. Power is automatically turned

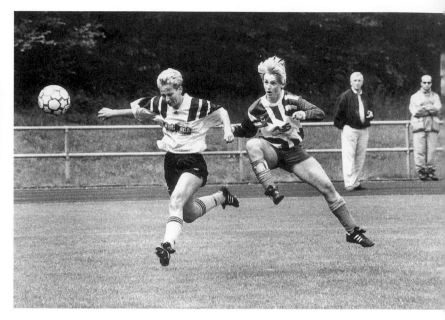

Sports and action shots are perfect subjects for flash photography. Here the light from the flash improved the otherwise flat lighting, helping the figures stand out against the background.

off after 90 seconds of non-use to prevent unnecessary battery consumption. Power is restored when the camera's shutter release button is pressed halfway or the test firing button (labeled "PILOT") is pressed.

Note: If the main switch is in the "SE" position while the Interval Timer function on a Canon Command Back E1 is operating, power

The main switch of the Speedlite 540EZ has three settings: O (off), I (on), and SE (Save Energy mode).

to the flash is automatically turned on one minute before the picture is taken. This assures a correct exposure and conserves battery power.

Mode Memory Function

When the 540EZ's power is turned off, its memory holds all settings, including flash mode (A-TTL/TTL), zoom head position, and flash exposure compensation. When the flash is reactivated, all previous settings are restored. This is a very practical feature, as the photographer can pick up right where he or she left off.

Note: To preserve the memory function while the batteries are being changed, first turn off the main switch on both the camera and flash before removing the old batteries, then exchange batteries within 60 seconds.

Ready Lamp and Test Flash Firing Button

The 540EZ's ready lamp is located on the back of the flash and is labeled "PILOT." This lamp indicates when the flash is charging, when it is fully charged, and when it is pressed it triggers a test flash.

When the flash's power is turned on (the "I" setting on the main switch), the flash begins charging. The ready lamp glows green until the unit is fully charged, at which time it turns red. If you wish to test fire the 540EZ to make sure the flash is operating, press the PILOT lamp while it is glowing red. This confirms that the flash will fire, however no metering is provided.

Test firing is not possible while the EOS camera's metering circuits are active (during the 8 seconds after the shutter release button has been partially depressed).

Flash Recycle Time and Quick Firing Mode

Canon designers realized the importance of having short recycle times available in the 540EZ for situations that require that photos be taken in rapid succession, such as sports or fashion

photography, for instance. To fulfill this need, they incorporated a Quick Firing mode in the 540EZ in addition to its normal full-power mode.

In Quick Firing mode, the flash can be fired numerous times in succession before it is fully recycled (see chart on page 52 for recycle times). To know which mode is active, simply look at the color of the ready lamp (PILOT). Quick Firing mode is available as soon as the lamp glows green. Normal full-charge firing is not available until the lamps glows red.

The ready lamp (labeled "PILOT") lights green when the 540EZ is in Quick Firing mode. It lights red when it is in normal, full-charge firing mode.

The advantages of fast recycling (from 0.2 to 2 seconds) are obvious in photojournalism and in any fast-changing situation when you want to capture the "Decisive Moment" on film. This advantage is gained at the expense of range, however, because the flash is not 100% charged when the ready lamp glows green. Consequently, underexposure is possible, so check the flash exposure confirmation lamp (a feature unique to the 540EZ) after the picture is taken. If the lamp does not light to confirm good flash exposure, adjust your distance or exposure settings and try again.

Unlike the earlier Speedlite 430EZ, Quick Firing can be used with the 540EZ with either AA batteries or an external power source. If you find that good flash exposure is frequently not confirmed (due to an insufficiently charged flash), you may want to try NiCd batteries or one of the remote power packs, which provide faster recycling. Also, note that when using flash in dark conditions, especially with distant subjects, all flash power is expended. Hence, recycling times will be quite long. If you require faster recycling times than the flash unit is delivering, a faster film (such as ISO 400, 800, or 1000) can be used. This results in an

increased guide number and reduces the recycling time because the flash's full charge is not expended in order to light the subject adequately.

Quick Firing is set automatically:

❏ In A-TTL mode when the camera is set for single-frame film advance.
❏ In TTL mode when the flash head is oriented in the normal (straight ahead) or 7° downward position.

Quick Firing is not possible in TTL flash control:

❏ When the EOS camera's film advance mode is set for continuous film advance.
❏ When the camera is set to Manual operating mode, or when the TTL Hot Shoe Adapter accessory is being used.
❏ When the flash is set to Manual flash mode at the 1/1 and 1/2 power level settings.
❏ When the flash head is tilted or swiveled to any orientation (other than the 7° downward position).

In the heat of the moment, one might fire away at such a fast rate that the Speedlite 540EZ cannot keep up—even in Quick Firing mode. If the camera is set to an autoexposure mode, it will automatically adjust its exposure settings in an attempt to produce a correct exposure without flash. However, this may require a longer exposure time and produce a blurred image due to camera shake. If the flash is charged adequately for the next shot, the lightning bolt symbol will glow in the camera's viewfinder, and the flash will fire when the shutter release is pressed.

Caution: Some independent manufacturers offer external power sources consisting of a rechargeable sealed lead acid (or similar) battery such as the Quantum® Turbo®. These provide nearly instantaneous recycling and numerous bursts. Canon does not vouch for the compatibility of such batteries, although they are often used by professional photographers. If considering such an accessory, review the warranty offered by the manufacturer. Should it damage a Speedlite, the Canon warranty will not be valid.

BATTERY LIFE AND RECYCLE TIMES

Power Source	Number of Bursts	Quick Firing Recycle Time	Normal Firing Recycle Time
4 AA Alkalines (in flash)	100–800	0.2–2 sec.	0.2–12 sec.
4 AA NiCds (in flash)	50–350	0.2–1.5 sec.	0.2–6 sec.
Transistor Pack E (with 6 alkalines)	400–2500	0.2–1.5 sec.	0.2–5 sec.
Transistor Pack E (with NiCd Pack)	350–2000	0.2–1 sec.	0.2–3 sec.
Compact Battery Pack E (with 6 alkalines)	400–2500	0.2–1.5 sec.	0.2–5 sec.

Note: In the Number of Bursts column, the first number indicates the approximate number expected in Manual full-power (1/1) mode and the second indicates the number expected in A-TTL mode with the 540EZ. In the Recycle Time columns, the first figure indicates the recycle time in A-TTL mode and the second in Manual full power (1/1) mode. All specs are estimates provided by Canon using their Standard Test Method. No information was provided for lithium AA batteries. Actual results may vary, but this data is useful for comparison purposes.

Flash Exposure Confirmation Lamp

The 540EZ is the first Speedlite to feature a flash exposure confirmation lamp. This LED is unlabeled and is located on the back of

the flash unit, to the right of the ready lamp (PILOT). After an exposure has been made, it glows for two seconds if there was adequate flash exposure. For more information, see page 78.

Flash Coupling Range Distance Scale

The 540EZ and 430EZ have distance scales on their LCD panels. This scale is useful when the EOS camera is operated in modes other than Program AE or Full Auto, when standard TTL flash control is provided rather than A-TTL. With TTL flash, the photographer must assess whether the subject is located within the flash's range.

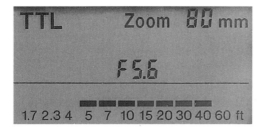

The 540EZ's LCD panel features a coupling range distance scale, which shows the flash's range at a given setting. As long as the subject is within this range, it should be correctly exposed.

The flash coupling distance range scale displays the range of the flash, given the camera's exposure settings. Numbers along the scale range from 1.7 feet to 60 feet (or 0.5 to 18 meters). A series of dashes above the numbers indicates the range of the flash at the set aperture (f/stop). The flash coupling range distance is greatest with wide apertures such as f/2 to f/5.6 and is more limited with small apertures such as f/16 or f/??

Note: The scale refers to the distance from the Speedlite to the subject, *not* to a distant background.

Using the Zoom Head

The Speedlite 540EZ features an internal motorized mechanism that automatically adjusts the flash coverage angle to match the lens' focal length from 24mm to 105mm. This feature has many advantages. Its automatic zoom control is especially helpful when a zoom lens is used, as the photographer does not need to re-adjust the head when switching to longer or shorter focal lengths, and the chance of photographer error is eliminated (unless, of

course, you have chosen to adjust the head manually). The automatic zoom head also prevents recording dark corners in the image, caused by an overly narrow angle of coverage, and maximizes power output for longer focal lengths. The system is extremely efficient. With telephoto lenses there is no wasted light as the beam is concentrated over a narrower angle.

Automatic Zoom Head Operation

The motorized reflector of the 540EZ automatically matches the focal length of the lens in use, whether it be a prime (single focal length) or zoom lens. The zoom head has seven settings: 24mm, 28mm, 35mm, 50mm, 70mm, 80mm, and 105mm (which is useful with longer focal lengths as well).

To enable the 540EZ's auto-zoom function, press the ZOOM button until only the word "Zoom" appears. At this setting the flash head will adjust automatically to match the focal length of the lens in use. This is what it would look like if a 50mm lens were mounted.

To access this automatic function, first turn on the camera and then turn on the flash ("I" setting on the main switch). When the shutter release is pressed halfway, the flash head zooms to the corresponding focal length, the word "Zoom" appears on the LCD panel, and the zoom head setting (focal length) is displayed. If "M Zoom" is displayed in the flash unit's LCD, indicating manual zoom operation is set, press the button marked "ZOOM" on the back of the unit until only the word "Zoom" is displayed instead. We have one slight criticism regarding the design of the controls, however—although the recessed buttons prevent inadvertent settings, they can be difficult to activate with the finger.

The zoom head and guide numbers: As you may have guessed, the guide number changes according to the zoom head position, increasing at the longer settings and decreasing at the shorter settings. This is because flash illumination spreads over a different area depending on the zoom head setting. For example, with ISO 100 film, a guide number of 92 in feet (28 in meters) at the 24mm setting becomes 177 in feet (54 in meters) at 105mm.

Manual Zoom Head Operation

The seven zoom settings can also be set manually. We rarely use the manual zoom head control, but it can be useful when you want to diffuse the light. For example, with a 100mm lens and a nearby subject, you may choose to set the flash zoom head to 28mm to soften the lighting somewhat. Check the current effective range of the flash on the LCD panel. It will be lower because the light is spread over a larger area. Considering the 540EZ's high guide number, however, this will rarely be a problem. Make sure the subject is not beyond flash range by checking the distance scale on the lens for the subject's actual distance from the flash. Remember, the guide number increases or decreases relative to the zoom head setting.

Hint: Be careful not to use a zoom head setting *longer than* the lens' focal length. This causes vignetting (dark areas near the edges of the film frame). The zoom head setting should be equal to or less than the focal length of the lens in use.

To control the flash's zoom head operation manually, press the ZOOM button on the back of the flash unit until "M Zoom" and one of the seven focal length settings appear on the LCD panel.

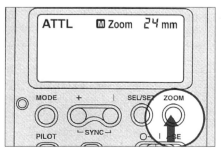

You can set the zoom head manually to correspond to the lens' focal length by pressing the ZOOM button. "M Zoom" and the focal length of the lens in use will be displayed.

Each time the button is pressed, the zoom head position increases and the current setting is displayed: 24mm, 28mm, 35mm, 50mm, 70mm, 80mm, 105mm, and "Zoom" (indicating automatic zoom head operation). When the "Zoom" setting is reached, the cycle begins again at "M Zoom 24mm" with a press of the ZOOM button.

Wide-Angle Diffusion Panel
Because ultra wide-angle lenses are becoming more and more popular, the 24mm flash head setting is too narrow for 18mm and 20mm lenses or the short end of a Canon EF 20-35mm zoom. To accommodate this need, the 540EZ features a built-in wide-angle diffusion panel, which can be pulled down over the flash head in order to spread the light farther. This panel is helpful with lenses of focal lengths from 18mm to 23mm, although the guide number is reduced to 52 in feet (16 in meters) because the light is spread out over a much wider area.

 To use the wide panel, gently pull it out from its seating at the top of the flash reflector and let it swing down. With this in place, the light is diffused and the entire film frame is illuminated when an ultra wide-angle lens is mounted. Once this is done, the zoom head automatically switches to the 24mm position and the ZOOM button is disabled—any other zoom head setting would not achieve the desired effect. The wide-angle diffusion panel should be used only when the flash head is in the normal (straight ahead) position or angled downward at the 7° click stop.

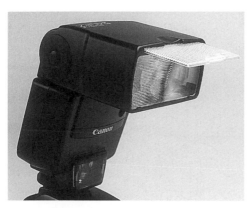

If you want to use the Speedlite 540 EZ's wide-angle diffusion panel for focal lengths as short as 18mm, pull it out ...

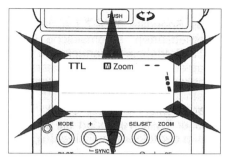

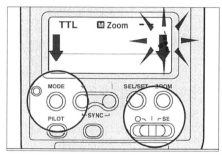

The wide panel is not intended to be used in conjunction with bounce flash. If you tip the reflector head up to bounce the flash from a ceiling while the diffusion screen is in place, the entire LCD panel blinks as a warning that exposure will be poor.

If the wide panel accidentally separates from the flash unit, you can reactivate the flash's ZOOM capability by pressing the MODE and ZOOM buttons simultaneously while moving the main switch from O through I to SE. Although this reactivates the flash unit's zoom function, you will need to take the flash unit to a Canon service center to have the panel reinstalled.

If the flash head is set to a bounce position while the wide panel is in place, both bounce flash and direct flash may illuminate the subject, producing poor results. In such an instance, the flash unit's entire LCD panel flashes as a warning, suggesting that you retract the wide panel. However, if you want to experiment with bounce

... and flip it down over the flash head. The ZOOM button on the Speedlite is disabled when the wide panel is used.

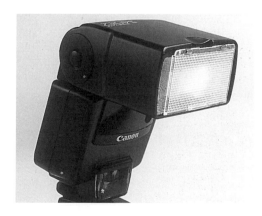

flash while using the wide panel, the following trick can be employed: To reactivate the ZOOM button and thereby regain control over the flash head setting, simultaneously press the MODE and ZOOM buttons on the back of the flash. While holding them in, move the flash's main switch from "O" to "I," and finally to "SE." The ZOOM button will then function, however the bounce flash symbol will continue to flash in the flash unit's LCD as a warning.

Note: The above procedure will be essential for normal operation if the wide panel should accidentally break loose from the flash unit. Should this occur, send the Speedlite 540EZ to the nearest Canon service center for repair or see your Canon dealer.

Bounce Flash

The Speedlite 540EZ has a moveable head that can be tilted or rotated from its normal, straight-ahead position. The head can be tipped up at a maximum of 90° and downward a maximum of 7°. The angle settings are indicated by a symbol on the LCD panel. Shooting straight ahead without tilting or rotating the flash head produces the somewhat flat yet harsh lighting common in many snapshots. With the Fresnel lens covering the flash tube of today's Speedlites, this effect is not nearly as unpleasant as with flash units of the past. Even so, bouncing the light off a ceiling or side wall produces indirect lighting, which can be more pleasing.

A point of light reflected from your subject's eyes can add life to a portrait. Using the built-in wide panel of the Speedlite 540EZ as a reflector in conjunction with bounce flash can provide a catchlight effect. For more information on using bounce flash or creating catchlights, see the appropriate sections in the *540EZ Advanced Techniques* chapter.

Selecting Flash Modes

The Speedlite 540EZ offers three different firing modes that can be selected with a touch of the MODE button: A-TTL/TTL automatic flash mode (either Advanced-TTL or standard TTL is selected auto-

Press the left-right bounce latch (labeled "PUSH" on the back of the flash head) to swivel the head to the left or right. Press the up-down bounce latch (on the right side of the flash head) to tilt the head upward or downward. If the reflector is swiveled or tilted out of its normal, straight-ahead position, the LCD panel displays a symbol resembling the flash head's bounce position.

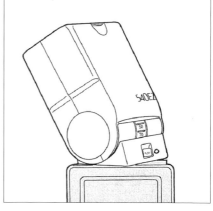

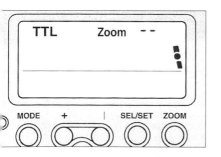

matically by the flash depending upon the operating mode selected on the camera), Manual (M) flash mode, or Stroboscopic ("MULTI") flash mode.

To select a flash mode, press the MODE button on the back of the flash unit until the desired symbol appears on the Speedlite 540EZ's display panel. The cycle follows the order: A-TTL/TTL, M, MULTI, and then the cycle repeats beginning with A-TTL/TTL.

Note: If the EOS camera is in Full Auto, Program, a Programmed Image Control (PIC) program, or the Depth-of-Field AE program (DEP) mode, the flash (if it is pointing straight ahead) will automatically select A-TTL rather than TTL mode. If the camera is in one of these modes and the flash head is tilted down to its 7° position, the flash unit will also automatically select A-TTL mode. However, if the flash head is tilted upwards or rotated for bounce

59

flash, the 540EZ will not work in A-TTL, regardless of the mode set on the camera. The 540EZ will automatically select TTL mode instead.

LCD Panel Illumination

When using flash under poor lighting conditions, the display on the LCD panel can be difficult to read. However, it can be illuminated. To do this, press the small, black button located to the left of the MODE button; this is recessed, so you may need to use a long fingernail or a pointed object. The panel is bathed in a green light for about 8 seconds after the button is pressed. If you need less time to make adjustments, press the button a second time to turn the light off.

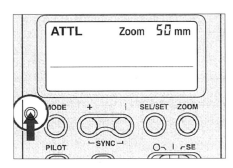

In order to be able to read the displays on the Speedlite 540EZ in low light, press the LCD panel illumination button. The LCD light shuts off automatically after about eight seconds. To turn it off manually before the eight seconds elapse, press the button again.

Autofocus Auxiliary Light

Thanks to advances in AF technology, the current EOS cameras can focus in poor lighting conditions, but no system is perfect. In low light, with dark subjects, or with subjects of low contrast (such as a bare wall), the AF sensors have to struggle. When the Speedlite 540EZ is attached and activated in such situations, it projects a near-infrared patterned beam of light as a target for the autofocus system to read. When used with the EOS-1N or 1N RS cameras, the 540EZ projects a pattern that corresponds to the camera's five focusing points. Its effective operating range is 1.7 to 49.5 feet (0.5 to 15 meters) at the center focusing point, and the effective operating range for the left and right sensors is 2.3 to

19.8 feet (0.7 to 6 meters). This autofocus auxiliary light is emitted only when the camera is set to One-Shot AF mode.

Other EOS cameras with multiple focusing points and built-in flash units have a built-in AF auxiliary light. When such models are used, the camera's autofocus assist light overrides that of the 540EZ. When the 540EZ is used with a camera with a single focusing point, only the central AF auxiliary light is active.

Speedlite 540EZ Specifications

Together with Canon cameras, Canon Speedlites make a photographer's life easier, producing photos that would otherwise be impossible or at least very difficult to achieve. Even the most basic listing of the specifications of the 540EZ flash unit is impressive.

Type: Clip-on type automatic flash unit with direct coupled contacts. Includes an AF auxiliary light, which corresponds to five focusing points (for the EOS-1N); A-TTL pre-flash; auto zoom head; and rotatable and tiltable head for bounce flash.

Guide number: The guide number at ISO 100 varies depending on the focal length of the lens in use and the corresponding position of the zoom head. The numbers provided are for full-power firing. At a focal length of 18 with the wide-angle diffuser in place, the guide number is 52 in feet (16 in meters). The following values hold for the range between 24mm and 105mm: 24mm: 92 in feet (28 in meters); 28mm: 98 in feet (30 in meters); 35mm: 118 in feet (36 in meters); 50mm: 136 in feet (42 in meters); 70mm: 151 in feet (46 in meters); 80mm: 164 in feet (50 in meters); and 105mm: 177 in feet (54 in meters).

If higher-speed films are used, the guide number increases. Simply multiply the guide number by a factor of 1.4 for each full increase in film speed. See page 24 for more information.

Battery life: Using four AA alkalines, it will produce approximately 120 to 800 bursts, or up to 400 to 2500 when using either the Transistor Pack E (NiCd or alkaline set), or the Compact Battery Pack E (see the chart on page 52 for more information). These values are somewhat theoretical as the number of possible flashes

depends on the remaining capacity of the batteries and the operating temperature. Another factor that plays a role is whether full output is required frequently or only occasionally. The actual number of flashes obtained can vary greatly from the values provided.

Flash duration: 1.2 milliseconds or shorter with normal firing; 2.3 milliseconds or shorter while quick firing.

Coverage angle: In auto zoom mode, the beam angle adjusts automatically to the focal length of the lens (even zoom lenses) at settings of 24, 28, 35, 50, 70, 80, and 105. In manual zoom mode, the head position can be set manually by pressing the ZOOM button. When the wide-angle diffusion panel is used, flash coverage for ultra wide-angle lenses is possible to 18mm.

Flash operating modes: Normal firing, quick firing, stroboscopic flash (strobe frequency and number of bursts able to be set in 31 steps), pre-flash in A-TTL mode (for estimating distance), and test firing possible.

Flash head settings:

Direction	Maximum Rotation Angle	Click Stops
Up	90°	0°, 60°, 75°, 90°
Left	180°	0°, 60°, 75°, 90°, 120°,150°, 180°
Right	90°	0°, 60°, 75°, 90°
Down	7°	0°, 7°

Exposure control modes: A-TTL program automatic flash, TTL program automatic flash, Manual.

Flash metering system: TTL automatic flash control of light reflected from the film plane. The film speed setting is automatically transferred from the camera to the flash unit.

Flash exposure compensation: Automatically reduces flash output in daylight fill-flash situations. Compensation can be set manually on the flash in a range of +/– 3 stops in 1/3-stop increments (in all

shooting modes except EOS cameras' fully automatic modes). With some EOS models (such as the EOS-1N, 1N RS, and EOS-A2/A2E) flash exposure compensation can be set from the camera.

Flash coupling range (with a 50mm f/1.4 lens and ISO 100): In A-TTL mode: from 1.7 to 99 feet (0.5 to 30 meters). In Quick Firing mode: from 1.7 to 25 feet (0.5 to 7.5 meters) minimum or 1.7 to 69.3 feet (0.5 to 21 meters) maximum.

Fastest flash sync speed: With the Rebel X (EOS 500), EOS Rebel (1000), and the EOS Rebel II (1000N): 1/90 second. With the EOS Elan (EOS 100), EOS 700, EOS 10S (10), EOS RT, EOS 630 (600), 650, 750, and 850: 1/125 second. With the EOS A2/A2E (5) series: 1/200 second. With EOS 620, EOS-1, and EOS-1N/1N RS: 1/250 second.

Flash ready indicator: When the flash unit's ready lamp (PILOT) glows red, normal firing is possible at full charge. If the ready lamp glows green, Quick Firing is possible at partial charge.

AF auxiliary light: Corresponds to five focusing points of the EOS-1N. Center focusing point: approx. 1.7 to 49.5 feet (0.5 to 15 meters) in dark conditions. Left and right focusing points: approx. 2.3 to 19.8 feet (0.7 to 6 meters) in dark conditions.

Power sources: Available power sources are: four AA alkaline batteries (LR6/AM-3); four AA rechargeable NiCds (KR15/51); or four AA lithium batteries (FR6).

External power sources: Transistor Pack E (takes six AA alkaline batteries [LR6/AM-3]); Battery Magazine TP (holds six C-size alkalines [LR14/AM-2]); NiCd Pack TP.

Save Energy function (SE): When the main switch is set to SE, power to the flash unit is automatically switched off after 90 seconds of inactivity.

Mode memory: The Speedlite 540EZ automatically stores all status information in its memory, including the operating mode and zoom head position when the power is turned off. Information is also

retained for approximately 60 seconds while batteries are being changed.

Dimensions (w x h x d): 3-1/8″ x 5-7/16″ x 4-7/16″ (80 mm x 138 mm x 112 mm).

Weight (without batteries): 14.2 oz. (405 g).

When a daylight-balanced color transparency film is used to photograph ⇨ interiors without the benefit of flash (above), the colors look unusually warm due to the tungsten lighting. Using flash gives a sharper picture and a more accurate rendition of the room's colors.

65

It is smart to keep a Speedlite 540EZ handy at all times—even when you are on vacation. The picture on the left was exposed using existing light. On the right, Program mode was used with A-TTL fill flash, which

enhanced the detail in the foreground without affecting the background exposure.

This photo of a lilac-colored poppy was made without flash.

Here, fill flash from the 540EZ was used to bring out the flower's true beauty.

Perfect lighting is not always possible in close-ups because of the limited flash-to-subject distance. However this shot, taken with the Canon EF Macro 100mm f/2.8 and the Macro Ring Lite ML-3, turned out well and the flower is larger than life size when enlarged to a 5" x 7" print.

Multiple flash units can be used to illuminate your subject more evenly. The main flash unit is mounted to the camera and set in TTL mode, while the second flash unit is held up and to the side by the photographer. Photo by Peter K. Burian.

Using the 540EZ in A-TTL and TTL Mode

Quick Start—A-TTL Flash Control

Using the 540EZ with an EOS camera set to Program AE or Full Auto mode lets you take flash pictures easily in almost any general situation, reducing the chance of photographer error, whether shooting indoors in low light or outdoors in sunshine. In Program AE or Full Auto mode, the camera automatically sets the appropriate sync speed and aperture, and the flash automatically selects A-TTL (Advanced TTL) automatic flash mode.

How to Use Flash in Program AE and Full Auto Mode

1. After mounting the Speedlite 540EZ onto any EOS camera, turn both the flash unit and camera on.
2. Select Program AE or Full Auto mode on the camera. A-TTL mode should appear automatically on the flash unit's LCD panel if the flash is set straight ahead or to the 7° downward position. (If the flash head is set to bounce operation, TTL flash mode is automatically activated.)
3. Aim the camera at the subject.
4. Press the shutter release halfway. When this is done, the camera sets focus and the 540EZ fires a pre-flash, which allows the camera's microcomputer to evaluate the subject's distance and reflectance.
5. With that information, the EOS camera sets the optimum aperture and shutter (sync) speed: usually between 1/60 second and the camera's top sync speed, depending on the model in use.

◁⟅ **Portraits of people with props are often more interesting than tight head-and-shoulders shots. In the top photo, direct flash made the colors vibrant but also created distracting shadows behind the subject. Setting the Speedlite to a bounce position eliminated the shadows, but the color of the bounce surface gave the image a warm cast.**

6. If the flash ready symbol (a lightning bolt) appears in the view-finder and neither the aperture nor shutter speed numeral blinks, the flash is fully charged and the camera is ready for you to take the exposure.

7. Press the shutter release fully.

8. Flash output is automatically reduced in bright conditions so that the correct amount of fill flash will be produced, creating a natural-looking image and not overpowering the ambient light.

9. If exposure is correct, the flash exposure confirmation lamp on the back of the 540EZ illuminates for about two seconds. If flash was insufficient to produce a good exposure, the con-firmation lamp does not illuminate. In that instance, position the camera and flash closer to the subject.

For taking completely automatic flash pictures, select Program or Full Auto exposure mode on the EOS camera. Then turn the Speedlite 540EZ on, and press the MODE button until A-TTL is displayed on the LCD panel. Point the camera at the subject, press the shutter release partway to acti-vate autofocus and fire the preflash. Then, if noth-ing is blinking and the flash ready indicator is illuminated in the view-finder, you can take the picture.

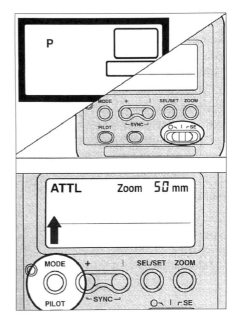

Note: If the camera is in DEP (Depth-of-Field AE mode) during a flash exposure, the camera functions as if it were in Program mode.

A-TTL Pre-Flash

In order to predetermine the exact aperture most likely to produce a correct exposure, the 540EZ emits a visible, near-infrared pre-flash of light when set in A-TTL flash mode. This pre-flash measures the flash-to-subject distance. In EOS cameras that have Program and/or Full Auto modes, the camera's ambient metering system calculates the aperture value required for correct background exposure, and compares it to the aperture required based on the information gathered by the pre-flash. The camera's microprocessor then selects the smaller of the two apertures and a sync speed that will provide good exposure up to the Speedlite's maximum flash range. This method ensures correct exposure of the available light in bright shooting conditions, using the flash as fill. In dark conditions, the distance-based aperture value is usually selected, with the flash used as the main light. As a result, fully automatic, intelligent flash exposure, up to the Speedlite's maximum range, is ensured in any lighting condition. This system saves the photographer from having to make a lot of complex calculations, as well as time and frustration.

A-TTL automatic flash control is available with the 540EZ and all Speedlites mentioned in this guide except the Macro Ring Lite ML-3, the 380EX, and the built-in, pop-up flashes of some EOS cameras. (The 380EX provides E-TTL flash mode instead, which will be described later.)

Automatic Fill Flash

Even in bright sunlight, a supplementary light source is beneficial to soften hard shadows or to avoid underexposing the primary subject in a backlit situation. In these conditions, flash output is reduced in order not to overpower the ambient light, so that the obvious fill-flash look does not occur. Naturally, in very bright conditions, a small aperture—such as f/16—may be selected by the system. This produces an extensive range of sharp focus, so the background will not be blurred to obscurity. Use the camera's depth-of-field preview control to asses the zone of apparent sharp focus.

If a wider aperture is important in order to blur a cluttered background, switch to a lower ISO film, perhaps ISO 50 instead of ISO 200.

The Speedlite 540EZ was used to provide fill lighting so that both the view outside through the window as well as the room's interior are exposed correctly.

The Value of Fill Flash

When flash is not used outdoors in situations of extremely bright backlighting, the subject is likely to be too dark (underexposed) in the final photo. If the exposure were set to produce a bright subject, the background would be excessively bright or washed out. The problem is, that such high-contrast situations include a tonal range (from light to dark) that is far beyond the latitude (recording ability) of the film. In order to even out the lighting, flash should be used to prevent an unnatural imbalance between the two elements.

Fill flash is used not only in backlit situations, but also with hard side light or when the sun is high in the sky (noon), which creates shadows under the subject's nose and around the eyes. (Naturally, fill flash can and should be used on subjects other than people, such as still lifes.)

When the camera is in Program or Full Auto mode, the A-TTL flash output is reduced to achieve a well-balanced relationship

between the illumination in the foreground and background. The same holds true when fill flash is used in TTL mode as well. In the past, in order to obtain the same result a good deal of flash experience was required.

TTL Automatic Flash Control

All of the EOS camera operating modes are compatible with TTL flash exposure metering. Once the Speedlite 540EZ is mounted on the camera, simply select the desired operating mode on the body. If the camera is in Aperture-Priority (Av), Shutter-Priority (Tv), or Manual (M) mode, the Speedlite 540EZ switches automatically from A-TTL to standard TTL automatic flash control.

Press the camera's shutter release button halfway. The f/stop and shutter speed are set just as in non-flash photography. Depending on the operating mode of the camera and the fastest flash sync speed of the model in use, the exposure values are selected as follows:

EOS Camera Mode	Shutter Speed Value	Aperture Value
Program AE (P) or Full Auto	Set automatically from 1/60 sec. to camera's top sync speed (except for Rebel cameras, which are set at 1/90 sec.)	Set automatically
Aperture-Priority (Av)	Set automatically from 30 sec. to camera's top sync speed according to ambient light	Set manually
Shutter-Priority (Tv)	Set manually from 30 sec. to camera's top sync speed	Set automatically according to ambient light
Manual (M)	Set manually from 30 sec. to camera's top sync speed	Set manually

If you select a shutter speed that is faster than the top sync speed of the camera in use in Shutter-Priority or Manual mode, the camera automatically changes the shutter speed to the fastest sync speed possible when the flash is charged. Once the shutter release is pressed, both the camera and the flash fire, and the image is recorded on film. The flash exposure settings are controlled by the TTL flash metering system, which takes the set aperture into consideration. The camera's system meters the light reflected off the film during exposure, and the flash is turned off automatically when the subject has been correctly exposed.

Background Exposure Control
The background is also taken into consideration in TTL flash mode. The background (ambient light) exposure is determined by the shutter speed-aperture combination just as in non-flash photography. As a result, one can influence the brightness of the background by choosing the right aperture (in Av mode) or the right shutter speed (in Tv mode).

As we'll see, the background can be made to appear lighter or darker (except in Program or Full Auto modes), so the photographer can control the atmosphere of the entire image. In Program or Full Auto mode, the camera selects the safest compromise between the flash-illuminated foreground and the ambient light in the background and converts this information into the correct exposure values. (Remember, exposure compensation can be used in any auto-exposure mode to vary the subject and/or background brightness.)

Flash Exposure Confirmation

When a flash exposure is made in A-TTL or TTL flash modes, the 540EZ's flash exposure confirmation lamp glows for two seconds if the flash exposure was adequate to illuminate the subject. (This lamp is unmarked and is located to the right of the ready lamp marked "PILOT.") If the flash exposure confirmation lamp does not come on, the picture will probably be underexposed. Either the subject was not as bright as the pre-flash indicated, or the flash was not 100% charged (as with Quick Firing mode).

Before trying to shoot the scene again, wait until the ready lamp glows red (not green), indicating a full charge. And for an extra

measure of safety, move closer to the subject. If the confirmation lamp glows this time, the exposure was adequate. If not, move even closer still, or switch to a higher ISO film to increase the effective flash range.

Flash with Aperture-Priority AE Mode

If manipulating depth of field is your primary consideration, set the Speedlite 540EZ and an EOS camera in its Av mode. You may want to use a wide aperture such as f/4 to achieve a shallow range of sharpness to blur away a distracting background. Or you may decide to set a small aperture such as f/22 for extensive depth of field in order to render all of the elements in a composition sharply. Use the camera's depth-of-field preview control to decide on the most effective f/stop in advance.

After the photographer selects an aperture, the camera automatically selects the appropriate shutter speed for good exposure. When the shutter is released, the EOS camera and 540EZ work together in TTL flash mode to light the subject well. When flash is activated, the primary goal of the computer is to properly light the subject, whether shooting indoors or out.

Note: The coupling range distance scale on the 540EZ provides information as to the flash's effective range at any selected f/stop. Do not ignore this information! If the subject is too close when a wide aperture (such as f/4) is used, it will be overexposed by flash. If it is too far away when a small aperture (such as f/22) is selected, it will be underexposed by flash. A compromise—selecting a smaller or larger aperture, or using a diffuser—will be required.

How to Use Flash with Aperture-Priority AE Mode

1. Turn the EOS camera and Speedlite 540EZ on.
2. Set the operating mode of the camera to Av.
3. Decide on an appropriate aperture, and turn the camera's dial to set this f/stop. The aperture value appears on the LCD panel of both the camera and Speedlite 540EZ.
4. The TTL symbol should appear on the flash unit's LCD panel. If not, press the flash's MODE button until it does.

5. Now, the EOS camera automatically sets a corresponding shutter speed to achieve proper background exposure within the camera's sync speed range.

6. Focus on the subject by pressing the shutter release halfway down.

7. Check the distance range scale on the flash's LCD panel to confirm that the subject is within the displayed range, particularly if the subject is very close or very distant from the flash. If not, set a different aperture (such as f/22 or f/4 instead of f/11).

8. The shutter speed numeral in the camera's viewfinder should not be blinking. If it is, set a different aperture until the blinking stops.

9. Check that the flash ready indicator (lightning bolt) is illuminated in the bottom of the viewfinder.

10. Press the shutter release all the way down to take the picture. It should be nicely exposed.

Hint: In Aperture-Priority flash photography, the system will set a slow shutter speed in low-light conditions in order to produce a bright background. Make sure the subject is not moving or it will be recorded blurry, which is not always the desired effect. When shooting with the EOS RT, EOS 10S (EOS 10), or EOS A2/A2E (EOS 5) in dark conditions, Custom Function 9 can be used to automatically set the shutter speed to the camera's top sync speed when in Av mode (this technique should not be used in bright conditions). Forcing the camera to select the fastest sync speed reduces the risk of ghosting (subject blur resulting from movement), but does restrict your choice of aperture. See the next section for more information about this.

Exposure Warnings in Aperture-Priority AE Mode
When the camera is set to Aperture-Priority mode with flash, the shutter speed numeral may blink in the camera's LCD panel and viewfinder. This indicates that the background, which is illuminated by ambient light, will be overexposed (too bright). If "30" is flashing, the background will be underexposed (too dark) as the shutter speed is too short for the aperture selected. In either case, set another aperture until the blinking stops.

Note: Having switched to another f/stop, you will no longer have the depth of field you had intended. As in many areas of photography however, a compromise is required. In this situation, you can stick to the desired aperture and accept inaccurate exposure of the background, or you can change to the "right" aperture for reasons of exposure, but accept more or less depth of field than you had originally intended.

Tips for Flash Photography in Aperture-Priority AE Mode

If the subject is too close for a correct flash exposure at the preferred aperture, try zooming the head manually to a wider setting or pulling the diffusion screen over the head, if required. Now close-distance flash operation will be possible without overexposing the subject, except at very wide apertures, such as f/2, perhaps.

If you are getting a warning that the background will be overexposed, switch to a slower (less light-sensitive) film—such as ISO 50 instead of 200. This also allows for shooting at close range while reducing the risk of the surroundings being washed out.

Frankly, we do not always consider Av mode suitable for low-light flash photography. Unless an ISO 400 to 1000 film is used, the shutter speed is often much too long for hand-holding the equipment, even using the widest aperture available with a zoom lens. In other cases, the subject is moving and calls for a faster shutter speed. Unless this special effect is intended, switch over to the camera's Program or Shutter-Priority modes for a faster sync speed. Now the background may not be as bright, but the subject will be sharply rendered without blurring.

Flash with Shutter-Priority AE Mode

When working with moving subjects, the Tv mode of an EOS camera, with TTL flash control, is the best option. Because fast sync speeds are selected by the camera's Program or Full Auto mode, you will use Shutter-Priority primarily for long sync speeds—down to a full 30 seconds—to blur motion to create a variety of "ghosting" effects. The subject will actually be recorded twice: once as "frozen" by the brief burst of flash and again as blurred by the long ambient light exposure. The creative potential is limited only by the photographer's imagination.

In addition, a long shutter speed is useful for producing a bright background exposure—of a friend in front of a city skyline, for example. The ambient light metering system will correctly expose the background, while TTL flash control will properly illuminate the foreground subject.

Note: Obviously, the above is possible in Aperture-Priority mode too, by selecting a smaller aperture to force a longer shutter speed. But when motion control is your primary intention, Shutter-Priority (Tv) mode is a more logical choice.

The system will set the appropriate aperture (f/stop) for an accurate background exposure. However, pay attention to the distance scale on the 540EZ's (and 430EZ's) LCD. Check it to determine whether the subject to be lit by flash is within range for the system-selected aperture.

How to Use Flash with Shutter-Priority AE Mode

1. Turn the EOS camera and Speedlite 540EZ on.
2. Set the camera to Tv mode.
3. Select the desired shutter speed, falling between 30 seconds and the camera's fastest sync speed.
4. Make sure the 540EZ is in the TTL mode. If it is not, press the MODE button until it is.
5. Point the camera's focusing point at the subject and focus by depressing the shutter release button halfway.
6. Make sure the viewfinder's f/number is not flashing and that the flash ready symbol (lightning bolt) is lit in the viewfinder. If the aperture value is blinking, change the shutter speed until the blinking stops.
7. In very low light, or if the subject is far from the camera, check the range distance scale on the 540EZ to make sure the subject is within the range displayed.
8. Press the shutter release completely to take the picture, which will be well exposed with TTL control.

Exposure Warnings in Shutter-Priority AE Mode

If the widest aperture number (such as f/4) flashes in the viewfinder when the trigger is lightly pressed, the background will be underexposed. Select a longer shutter speed with the camera's

dial. This will allow adequate exposure time for a dim background to register on film. When the smallest aperture (often f/22) flashes, the background will be overexposed. Select a shorter shutter speed for correct results.

Flash with Manual Exposure Mode

The Speedlite 540EZ works in all automatic exposure modes, but can also be used in the camera's Manual exposure (M) mode. In Manual mode, both the desired aperture and shutter speed are selected by the photographer. The distance to the subject must then be within the range shown on the flash unit's LCD panel. The advantage of using flash in Manual exposure mode is that the photographer can achieve the exact effect he or she desires for any given subject.

If the camera is in the M mode, the photographer must select both the shutter speed and the aperture (f/stop) using the control dials on the body. Any combination can be set, but the fastest acceptable shutter speed is the top sync speed of the EOS camera model in use. In this mode you get full control over depth of field (a wide or narrow range of apparent sharpness) and the rendition of motion (from frozen to blurred). Both factors can be controlled simultaneously.

How to Use Flash with Manual Exposure Mode

1. Turn the EOS camera and Speedlite 540EZ on.
2. Set the camera to M and the 540EZ to TTL mode.
3. Select the desired aperture and shutter speed on the camera, between 30 seconds and the fastest possible sync speed.
4. Press the shutter release lightly to activate autofocus, or focus manually.
5. Check the range distance scale in the flash unit's LCD panel to confirm that the subject is within its range.
6. If not, select a different aperture or shutter speed (or both), and check the distance scale again.
7. Before releasing the shutter, make sure that the flash-ready symbol (lightning bolt) appears in the viewfinder.
8. Now press the shutter release all the way to take the picture.

Note: If the subject is too close to the camera, an arrow flashes on the left side of the distance scale on the 540EZ. Move farther back. With wide-angle lenses between 18mm and 24mm, you must be no closer than 1.7 feet (0.5 meter) from the subject. With lenses of 35mm or longer, you must be no closer than 2.3 feet (0.7 meter) from the subject.

In order to illustrate the practical use of flash in the camera's Manual mode, consider the following hypothetical example: You are at a torch light parade at night with the camera mounted on a tripod. A long shutter speed will produce a sense of motion blurring the light from the torches, so you set 1/4 second. But you also need a small aperture in order to create depth of field wide enough to render the entire group of marchers as well as city hall in the background sharply.

You set f/16, but now the aperture and shutter speed signals are blinking in the viewfinder, suggesting that the background will be underexposed. So you switch to 1/8 second at f/11 and the blinking stops. This compromise is still close to your intended exposure settings, so you check the distance scale on the back of the 540EZ. The primary subject is only 10 feet (3 meters) away (which is within the flash range), so you trip the shutter. The burst of flash (with TTL control) should "freeze" the marchers for an instant so they will be recognizable.

Note: Again, the plus or minus exposure warnings in the viewfinder refer to the ambient light exposure. A plus symbol warns that the background will be overexposed. A minus symbol signifies that the background will be underexposed. Switch to a different aperture and/or shutter speed if an accurate rendition of the background is desired. Should you not make these changes, the subject should still be well exposed by automatic TTL flash control as long as it is within the flash range.

540EZ Advanced Techniques

The more one understands the Speedlite 540EZ's technical characteristics, the more one discovers creative options. For example, flash exposure can be controlled directly on the Speedlite 540EZ independent of the camera-selected ambient light exposure.

Flash Exposure Compensation

In the same way as ambient light is metered, flash exposure is calculated to produce a subject at 18% reflectance. If the subject's reflectance averages to be brighter or darker than 18%, the system will attempt to adjust exposure to make it 18% nonetheless. In such a situation, flash exposure compensation is required in order to record the subject more faithfully.

The EOS system automatically adjusts the flash exposure for fill flash in bright, outdoor conditions. However, with the 540EZ mounted, the photographer can increase or decrease the amount of compensation—in any situation—by up to +/– 3 stops in 1/3-stop increments. And some EOS cameras have a flash exposure compensation control built into the camera.

Note: With the EOS-1N and the EOS A2/A2E (5), flash exposure compensation can be set from the camera. However, if flash exposure compensation is set on the camera and on the 540EZ or 430EZ as well, the Speedlite's setting takes priority. With the EOS Elan (EOS 100), the camera's flash exposure compensation function controls only the built-in flash.

Setting Flash Exposure Compensation
With the 540EZ the procedure is both simple and logical:

1. Set the Speedlite to A-TTL or TTL mode by pressing the MODE button.
2. Press the SEL/SET (Select/Set) button on the back of the flash. The flash compensation indicator symbol (a lightning bolt with

a +/– symbol) and the currently set compensation value will blink in the 540EZ's LCD panel.

3. Press the "+" button for plus exposure compensation (greater flash output). Press the "–" button for minus compensation (less flash output for a more subtle lighting effect). Each press of the button changes the value by 1/3 stop.

4. If you want to stop the number and symbol from blinking, press the SEL/SET button. This is not really necessary, as the blinking will stop automatically after eight seconds. But any picture taken in the meantime will include the selected flash exposure compensation factor.

Press the SEL/SET button and then the + and – buttons to select the desired flash exposure compensation value. The selected value will blink on the display. When the SEL/SET button is pressed again, the blinking stops and the value is set.

When to Override Automatic Flash

In some situations it is essential to adjust the flash exposure in order to produce natural-looking results. Some conditions will "fool" even the most advanced A-TTL metering microcomputer, calling for user-override. Consider the following examples as a starting point. Then, gain some experience by shooting some film—preferably slides, because with slides there is no intermediate printing process that might alter exposure.

❏ If the background is distant and very dark (outdoors at night or in a large hall) and the subject is small in the frame, the flash may emit too much light. The subject will be overexposed because the system is attempting to illuminate the entire surroundings. As a starting point, try setting a –2 stop compensation on the 540EZ to reduce flash intensity.

❏ If the subject is extremely dark (such as a black cat against a dark sofa) the flash may again emit too much light as it attempts to render the subject as an 18% midtone (gray). As a general rule, if a black subject fills the fame, set a −2 stop compensation on the 540EZ. If it fills only half the frame, a −1 stop compensation may be adequate. The minus compensation renders the cat and its surroundings as it should be—dark. At a normal automatic setting, the results would be washed out.

❏ If a small or distant subject is placed against a bright background (perhaps a child building a sand castle on a beach) the flash may not emit enough light. In that case, the subject will be underexposed and silhouetted. Depending on the situation, set a +1 or +2 stop compensation on the 540EZ. Or shoot one frame at each setting. The more the subject fills the frame, the less compensation is required, as the camera's metering system is less affected by the background. This is also good advice for any standard backlit situation, for instance when the subject is in front of a window or outside with the sun coming from behind.

❏ If the subject itself is white (such as a bride against a white wall) some "plus" flash exposure compensation will be required to prevent the meter's inclination to render it as an 18% midtone. In this situation, generally a +1-1/3 stop compensation may be required. If a white subject fills only half the frame, a +2/3 stop compensation may be adequate. Again, if you are in a "once-in-a-lifetime" shooting situation, bracket your exposures to assure good results.

When compensation is not input by the photographer, the EOS system strives to produce a balance between background and foreground, within the limits imposed by the sync speed. As these examples indicate, it is not always successful under difficult conditions. Based on these hints—plus your experience with a specific EOS model—you can decide on a starting point for an appropriate flash exposure compensation strategy. If you wish to truly master flash, practice and experience will help you to discover how to get the best results from your equipment. The suggestions above are simply approximations or places to start.

Hint: Even in typical or "average" conditions, you may decide to set some flash exposure compensation regularly with slide film, especially with light-colored subjects. You may find that automatic fill flash is too overbearing for an outdoor portrait or for the flowers in the foreground of a landscape. In that case, try setting a –2/3 or –1 stop of flash exposure compensation in the next session. Keep notes and check the slides closely when they are processed. Rely on the experience gained from them when shooting fill-flash photographs in the future.

Note: Flash exposure compensation is not possible in Programmed Image Control (PIC) or in the Full Auto modes available on some EOS models. If flash exposure compensation is set, the metering system ignores the compensation factor entirely. Switch the camera to its standard Program AE, Aperture-Priority AE, or Shutter-Priority AE mode.

Balancing Background and Subject Exposure

Using Exposure Compensation and Flash Exposure Compensation

In some cases, you may want to control the brightness of the background to make it lighter or darker. This adjustment in density can completely change the way that the background relates to the subject in a photograph. The camera's exposure compensation control (for ambient light metering) can be used for this purpose.

The 540EZ's or 430EZ's flash exposure compensation control varies the duration of the flash independent of the camera's selection of aperture and shutter speed. Thus, it can be used to increase or decrease the brightness level of the primary subject, which is lit mainly by the flash. The camera's exposure compensation and the flash unit's flash exposure compensation controls are used in making creative decisions, not necessarily for accurate results. With both adjustments, plus compensation increases brightness, while minus compensation decreases brightness.

By using opposing exposure compensations on the camera and flash, the brightness values of the foreground and the background may be brought closer to one another. However, in order to arrive at reliable results, a few test exposures should be made.

Adjusting the ISO Film Speed

Another way to achieve both a brighter background and a brighter subject is to set the film speed to a lower ISO. For example, with ISO 100 film, you can set the camera to ISO 50 and process the film normally, without adjusting for the slower speed. This will render both the foreground subject and the background one stop brighter than usual. Setting the film speed to a higher ISO will make the foreground and background darker. However, care must be taken, because changing the film speed effectively changes the flash unit's guide number or shooting range.

With some EOS cameras, changing the film speed is often the only possible means of obtaining equal compensation, because ambient light exposure compensation is controlled in 1/2 stops and flash exposure compensation in 1/3 stops. If you want to bias both ambient and flash light exposure by the same factor, use the film speed dial to adjust exposure.

Other Background Exposure Control Options

Another technique used in flash photography is to control the background exposure without changing the level of flash illumination on the subject. You can then darken or brighten the background to achieve the intended effect. Remember, camera exposure compensation adjustments affect the exposure for ambient light. Flash exposure compensation changes the duration of the flash independent of the camera's selection of aperture and shutter speed. This is used to increase or decrease the brightness level of the primary subject, which is lit mainly by the flash.

However, it is important that the primary subject is within the range of the flash at the selected aperture, otherwise it will be over- or underexposed. If you are using the 540EZ or 430EZ, refer to the coupling range distance scale on the LCD panel. With other Speedlites you will need to use guide number calculations and apply the formula:

Guide Number ÷ Aperture = Subject Distance

For example, if you want to darken the background—perhaps because it is too bright or too cluttered—close down the lens' aperture. This will darken the background without affecting the exposure of the subject, which will be correct due to flash unit's TTL adjustment. To do this, try the following procedure:

1. Set the EOS camera to its fastest sync speed: this would be 1/90 second, 1/125, 1/200, or 1/250 second, depending on the model. This can be done quickly in Manual (M) or Shutter-Priority AE (Tv) mode.
2. Meter the scene as if you were not using flash, following the camera's viewfinder indicators to achieve "correct" exposure. Let's say that is f/5.6 at 1/125 second.
3. If you want to darken the background, close the aperture down anywhere from one to three stops, depending on the level of darkness you want to achieve. (Ignore the viewfinder's warning of incorrect exposure.) If you want to brighten the background, open the aperture up from one to three stops.
4. Activate the Speedlite in the TTL flash mode and take the picture.

Note: For this technique, do not set a shutter speed faster than the camera's top sync speed! If you set 1/500 second, for instance, the system will automatically reduce it to the fastest available flash sync speed when the Speedlite is turned on. Consequently, the results will be different than you intended.

After a few experiments with this technique, you should be able to achieve the desired effect on the first try! However, when in doubt, bracket your exposures.

Hint: When shooting backlit subjects in Manual exposure mode, shutter speeds of slower than 1/60 second are not very helpful for exposure compensation. And be aware that when making exposures with little available light, slow shutter speeds will produce motion blur.

Background Control with Slow Synchro Flash

Further background control is possible using slow synchro photography in three EOS operating modes and with the 540EZ set for TTL mode. Slow synchro flash is simply flash used with a slow shutter speed so that both the subject and a low-lit background are well exposed. The long exposure times (often several seconds) will require the use of a tripod to hold the camera steady, unless intentional motion blur is the desired effect.

However, with most EOS cameras in Program mode, you cannot predict how the background exposure will turn out. Hence, you have no idea as to which settings will create the specific effect you want to achieve. While the system will produce a satisfactory result (if you follow the instructions), you may not achieve the effect you intended. For the greatest feedback and user control in slow synchro photography, using an EOS-1, EOS-1N, or EOS-1N RS camera is recommended. These models include an exposure level indicator on the right side of the viewfinder. The background (ambient light) exposure can be determined by checking the position of the pointer along the scale. Much experience using this technique is required for predictable results. If in doubt, bracket your exposures.

Hint: In our experience, selecting Aperture-Priority AE (Av) mode is the most logical, simplest method for slow synchro photography. The computerized metering system will generally produce an exposure in which both the subject and background are brightly rendered. This is most often the desired effect. Do not select a Program or Full Auto mode unless you want a dark background!

Here are some tips to keep in mind:

❏ When the pointer is in the center of the scale, exposure for the background will be "correct"—about as bright as the subject.

❏ If you intentionally want a darker or lighter background, shift the ambient exposure compensation setting of the EOS camera. Watch the pointer drop or rise along the scale. For example, if it stops at two lines above the center, the background will be brighter than the subject by two EV (exposure values equaling two stops). If it stops at two lines below the center, the background will be two EV darker than the subject.

With any EOS model equipped with an exposure compensation scale, you can predict and control how the background will be rendered. When shooting several frames, you can change the effect from one photo to the next, if desired. While this may not be required frequently, it is another form of additional user control available with EOS cameras.

Indirect Flash

Indoor pictures with direct, on-camera flash as the main light are rarely crowd-pleasers. While on-camera fill flash with the 540EZ can produce pleasing results outdoors, bounce flash is a useful technique indoors in low-light conditions.

Direct flash is not only harsh, but creates a dark shadow on the wall or other surface behind the subject. This is almost always noticeable in the picture, a sure sign of a snapshot approach. Even still lifes are less than pleasing when direct, on-camera flash is used. For an entirely different effect, try bouncing light off a wall, ceiling, or other reflective surface such as a silver umbrella or large reflector panel such as the California Sunbounce®, available from The Saunders Group (address on back cover). This produces a larger light source in relation to the subject, resulting in softer illumination.

Although light is evenly distributed, a considerable amount of power is required because of the light's diffusion and the longer route it must travel: from camera, to bounce surface, and then to the subject. By doubling the distance, the intensity is reduced to about one-quarter because light loses power with the square of the distance it travels. For more information, see the discussion on the Inverse Square Law on page 12.

The 540EZ's guide number of 177 in feet (54 in meters) is one of the highest of any on the market, making bounce flash practical. The swiveling, tilting reflector head is particularly versatile and well suited to this type of photography. Granted, it is difficult to get a catchlight into a subject's eyes when indirect flash is used (unless you use the 540EZ's wide panel as a reflector, which is described on page 94). However, dark eye sockets are not usually a serious problem when you move farther back, because light does not strike the subject from directly above. In a moderately sized room (as in a house or apartment) some light will bounce back onto the subject from surrounding walls as well.

Multi-Positionable Flash Head

The Speedlite 540EZ's moveable flash head can be tilted and rotated in many positions. It has click stops at 60°, 75°, and 90° from horizontal when tilted upwards. It can also be rotated to the left at click stops of 60°, 75°, 90°, 120°, 150°, and 180°, and to

the right at click stops of 60°, 75°, and 90°. When the flash head is tilted or rotated, a symbol indicating one of three different kinds of bounce flash appears in the LCD panel: up/left/right position, catchlight position, or 7° down position.

Bounce Flash Operation
With TTL metering and the ability to rotate the flash head vertically and laterally, bounce flash operation is child's play with the 540EZ. The following procedure is quite simple.

1. First, turn the camera and flash on.
2. Press the up/down bounce latch on the right side of the 540EZ flash head to tilt the flash head up or down. Press the right/left bounce latch (labeled "PUSH" on the back of the flash head) for right or left bounce operation.
3. Rotate the head to aim the light at a surface beside the subject. Tilt it upwards to allow light to be bounced from the ceiling. It can be both rotated and tilted in order to direct light exactly where you need it, for maximum flexibility.
4. Once the flash head is rotated or tilted out of its normal, straight-ahead position, the appropriate bounce flash symbol will appear on the flash's LCD panel. The flash simultaneously switches to TTL mode and the zoom head shifts to the 50mm setting (if the flash is in auto zoom mode). Another focal length can be selected manually by pressing the ZOOM button.
5. Once the flash head is positioned, point the camera's active focusing point on the main subject and activate autofocus by lightly pressing the camera's shutter release button. This also activates the camera's metering circuits.
6. When the flash ready indicator (a lightning bolt) appears in the camera's viewfinder and neither the shutter speed nor aperture display is blinking, the indirect flash exposure can be completed by depressing the shutter release fully.

After the exposure has been made, if the flash exposure was adequate the flash confirmation light on the 540EZ glows for about two seconds. Thanks to TTL flash control, the resulting exposure should be correct. However, if the confirmation lamp does not come on, that indicates that the main subject was underexposed. In that case, try shooting the scene again with a faster film (higher

ISO number), move closer to the subject, or select a smaller f/number (a larger aperture), such as f/5.6 instead of f/11. This will permit more light to strike the film over the same exposure time. Or, as a last resort, you could try using direct flash instead.

Note: In bounce flash operation, the coupling range distance scales of the 540EZ and 430EZ do not operate. That is why it is very important to check the flash exposure confirmation lamp after the picture is taken to determine whether exposure was adequate.

Tips for Shooting with Bounce Flash

The first thing to remember when shooting with bounce flash is that you are working with reflected light. Bounced light will reflect the color of the surface it is bouncing off of onto your subject. So, if the reflective surface is colored or patterned (like wallpaper), the reflected light will be tinted or mottled as well. In order to obtain the best possible results with indirect flash, the reflective surface should be white or silver. Or, to alter the mood of the photo or produce more creative effects, you may wish to bounce light from a gold reflector or another colored surface.

Sometimes when flash is bounced from a ceiling, shadows fall in the subject's eye sockets. To minimize this effect, move farther back to avoid the near vertical (90°) bounce, which causes illumination to come directly from above the subject. If necessary, use a longer focal length lens to fill the frame.

Generally speaking, bouncing light from the ceiling with the flash angled at its 90° position (straight up) can be used to illuminate nearby subjects, while shallower angles are appropriate for shooting distant subjects in a large room. (The angle of incidence is equal to the angle of reflection.)

Creating Catchlights with Bounce Flash

Bounce flash rarely produces "catchlights," the bright spot of light that gives life to your subject's eyes in photographs. However in portraiture catchlights are often desirable, and they will appear in indirect flash exposures only if there is a highly reflective surface somewhere in the room.

If you want to be completely sure to produce catchlights in your subject's eyes, first tilt the flash head vertically to 90°. Then pull the wide panel out until it clicks, locking in place and extending

vertically from the flash head. If the wide panel comes out too far, gently push it back in and try again. Setting the screen in this position directs some light toward the subject while maintaining a bounce flash effect. Now continue as with normal bounce photography using the ceiling as the main reflective surface. This technique makes it possible to obtain reflections in the subject's eyes only if the subject is not farther than 5 feet (1.5 meters) away.

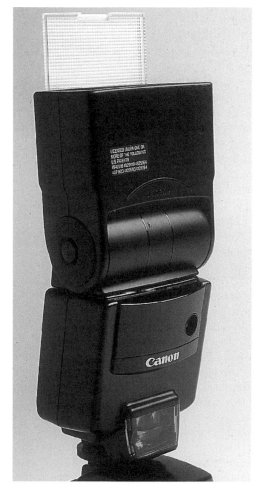

Create catchlights in the eyes by tilting the Speedlite 540EZ straight up and pulling the wide-angle diffusion panel out to its vertical position.

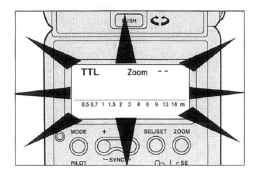

If you tilt the flash head down 7° with the wide-angle diffusion screen pulled out, the entire monitor blinks as a warning that the flash head is not set correctly for catchlight bounce flash.

Note: If the flash head is pivoted to the left or right, catchlights will not appear in the subject's eyes. This technique works only when the flash head is pointing 90° from horizontal. It is also important that the subject is not more than 5 feet (1.5 meters) from the camera. If the reflector is tilted down in its 7° position and the wide panel is pulled out to produce catchlights, the entire LCD panel blinks. This is a warning that the setting is incorrect and will not produce the desired result.

Accessories for Indirect Flash

The bounce surface of the built-in wide-angle diffusion panel is really quite small. To increase the bounce surface area for superior results, you can attach a large white index card to the flash head with a rubber band. With the flash head pointed straight up, tilt the card forward by bending it slightly. This will force some light to bounce off the card while the rest bounces off the ceiling.

Or, as an alternative try one of the aftermarket flash accessories such as those from LumiQuest®. Some accessories merely reflect light, while others also add a diffusion surface, providing softer illumination. Be aware, though, that the diffuser can reduce light transmission, often by about two stops. When using such an accessory, you may need to use faster film, unless the subject is quite close.

A silver or white photographic umbrella can also be used effectively for indirect flash, and with excellent results! The Speedlite can be used off-camera by attaching Canon's Off-Camera Shoe Cord 2, which maintains full flash communication through the

camera's hot shoe. Mount the flash and umbrella on a light stand situated above and to the side of the subject. TTL flash exposure control will assure an excellent photograph.

Flash Diffusion Techniques
When the subject is less than about 7 feet (about 2 meters) from the camera—whether a person, still life, or flowers—direct on-camera flash can be used to create pleasing results. However, this requires installing an aftermarket accessory over the flash head to create a larger surface producing a softer light source. Several brands are available on the market, but the most versatile are those that resemble a small "softbox," which enlarges the light source. Most softboxes consist of a frame with a dark cover and translucent material that covers the flash head reflector. Such devices are used with direct flash.

A flash modifier such as the LumiQuest Promax Mini Softbox or the Promax Softbox II can help diffuse light to achieve a softer lighting effect.

The Westcott® Micro-Apollo™, LumiQuest Promax Softbox, and the inflatable Photoflex® XTC™ II are but three examples of the many light diffusion products. The lighting effect varies depending on the type of accessory used, but all of them make

on-camera, direct flash a viable option with nearby subjects. Beyond 7 feet (2 meters) these accessories lose their effectiveness, as the flash becomes a smaller point light source in relation to the subject. We find these especially ideal for shooting still lifes at distances closer than one yard (or a meter).

Other accessories made by LumiQuest bounce some light from the ceiling, and the rest is emitted from the accessory itself. These types seem to produce the most effective results with portraits.

Off-Camera Flash Techniques
The best method for achieving pleasing flash effects with a single Speedlite is to remove the TTL flash unit from the camera using an Off-Camera Shoe Cord 2 as a connector. As a starting point, hold the Speedlite 45° above and 45° to the side of the subject. Take care to point the flash toward the appropriate area. For a portrait, that might be to the side and slightly above the subject, or in a nature close-up, you might put it behind a group of flowers to produce backlighting.

A flash bracket such as the Stroboframe Pro-T™ available from The Saunders Group (address on back cover) also takes the flash unit off-camera, increasing both convenience and stability, as well as eliminating red-eye and harsh side shadows.

Note: With any of the indirect flash methods described (bounce, off-camera flash), the red-eye syndrome commonly produced in a dark environment is reduced or eliminated because the light from the flash is not directly on the axis of the lens.

Using off-camera flash increases the distance range of the Speedlite, and the flash recycles more quickly. Unlike with bounce flash (which makes light travel over a greater distance), taking the flash off camera maintains the full power of direct flash.

Close-Up Photography with the 540EZ

Because the Speedlite 540EZ is quite large, its head sits fairly high above the lens. This helps prevent red-eye in people or animals when direct flash is used. However, this height can cause problems in close-up work because only the top part of the subject is

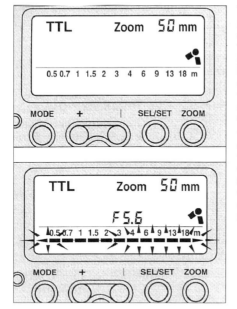

The Speedlite 540EZ's LCD panel displays a symbol indicating the position of the flash head. Here, the symbol indicates that the flash head is tilted down to its 7° close-up position. The bars to the left and right of the close-up range on the distance scale blink to indicate that the flash unit is in a close-up shooting position. All the bars on the coupling range distance scale blink if the subject's distance is not within the close-up flash coupling range.

fully illuminated. In order to avoid this, the head of the 540EZ can be tilted down 7° for more accurate flash coverage. Here's how to do it:

1. After turning the camera and flash on, press the up/down bounce latch on the side of the flash head and tilt the head down until it clicks into place (7°). A symbol resembling a downward tilting flash head appears on the 540EZ's LCD panel.

2. This position is effective only for close shooting distances from 1.7 to 6.6 feet (0.5 to 2 meters) with the flash head pointed straight ahead (i.e., not pivoted left or right). The rest of the scale blinks as a warning not to try this technique with subjects at other distances.

3. Due to the close distance of the flash to the subject, a small aperture such as f/16 will be required to prevent overexposure. This is generally appropriate in any event, in order to maximize depth of field, which is quite shallow in such close-up work. If you want less depth of field, switch to a slower (lower ISO) film, which will allow the use of a wider aperture.

4. Check the LCD panel of the 540EZ; the entire flash coupling range distance scale blinks if the f/stop selected will produce incorrect exposure. Switch to Program or Full Auto mode to select an aperture automatically, but remember, in A-TTL flash control the distance scale disappears.

For more on close-up photography, see the *Close-Up and Macro Photography* chapter.

Motion Blur with Second-Curtain Sync

When flash is used with long shutter speeds and you are shooting moving subjects, interesting effects can be achieved. The flash exposure freezes the subject with its brief burst of light, while the ambient light exposure produces a blurred trail evoking a sense of motion. The motion blur occurs because the subject moves throughout the long ambient exposure time; thus, both the ambient light and flash exposure are recorded on one photograph. The camera's ability to sync with the second shutter curtain is a very powerful creative tool. This technique, used with some expertise can produce unique flash effects or even make a seemingly impossible shot possible.

How It Works
In normal operation (which is actually first-curtain sync), the flash fires as soon as the first shutter curtain uncovers the entire frame. As a result, the moving subject is frozen at the start of its motion, and the blur occurs afterwards. In normal sync, the blurred trail *precedes* the subject, perhaps a jogger moving along a sidewalk, which looks completely unnatural to the eye.

Second-curtain (or rear-curtain) sync should be selected to record a moving subject with the 540EZ if shutter speeds of 1/15 second or longer are used. This causes the flash to fire at the end of the exposure, producing a "trailing-blur" effect on the film. In the torch light parade example cited earlier, a blurred trail behind the marchers creates a satisfying and logical illusion of motion in a still photograph.

If the camera is switched to a long shutter speed and the background is dark, the desired effect of recording speed and motion

is much easier to attain. On the whole, synchronization with the second shutter curtain should be done in conjunction with slow sync speeds of 1/15 second or longer. Hence using a tripod or other camera support is necessary to prevent undesirable blur resulting from camera shake.

Note: Second-curtain sync cannot be used when the camera is in Full Auto or any PIC mode, or in combination with Stroboscopic (MULTI) flash operation. Second-curtain sync cannot be activated or canceled while the display on the 540EZ's LCD panel is blinking after a setting has been made. In order to be able to do so, press the SEL/SET button on the back of the flash until the display is no longer blinking.

Setting Second-Curtain Sync
Second-curtain sync can be set by simultaneously pressing both sync timing buttons (labeled "+" and "–") on the back of the 540EZ or 430EZ. The second-curtain sync indicator (three arrows pointing right) appears on the flash's LCD panel. To return to first-curtain sync, press both buttons again at the same time (the second-curtain sync indicator will disappear from the LCD). With some EOS cameras, such as the EOS Elan (EOS 100), or Elan II/IIE (EOS 50/50E), a Custom Function can be used to select rear-curtain sync when the built-in pop-up flash is used. For more information on individual camera models, consult the *Magic Lantern Guide* for the specific EOS camera.

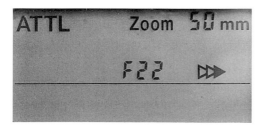

Second-curtain sync is used to portray motion realistically while using flash. To access this feature, press the flash unit's + and – buttons simultaneously. The symbol for second-curtain synchronization (>>>) appears on the LCD panel.

Fully Manual Flash Mode

Another feature of the Speedlite 540EZ is the ability for the photographer to decrease the flash output in order to match specific needs. We must admit that using the Speedlite 540EZ as a fully manual flash is considerably more complicated than with the A-TTL and TTL automatic flash control modes. Some photographers are immediately intimidated and avoid this option entirely. But those photographers who are very experienced with manual flash using older systems will find corresponding techniques relatively simple with the Speedlite 540EZ.

There are several applications for using fully manual flash, and they will reveal themselves to you the more experience you gain with flash photography. However, one of the most significant advantages to Manual flash mode is that by setting low power output such as 1/128, flash recycle is fast enough to keep up with a three frame-per-second continuous film advance (or even faster if a high ISO film is used).

Controlling the Power Output in Manual Flash Mode
In fully Manual flash mode, the 540EZ offers eight flash settings, ranging from full power, or 1/1, to 1/128 power. Adjustments can be made to the power output in full-stop increments by doing the following:

1. Set the camera's operating mode to Aperture-Priority AE (Av) or Manual (M) mode.
2. Set the Speedlite 540EZ to Manual (M) flash mode.
3. Press the SEL/SET (select/set) button. At that point, the output level will blink in the LCD panel.
4. Press the + or – button to increase or decrease the power output level. Each time a button is pressed the value is changed by one stop.
5. Once you have reached the desired power output level, press the SEL/SET button again to stop the value from blinking. (It will stop blinking automatically after 8 seconds in any case.)

Manual Flash Exercise
In this section we offer an exercise to make the thought of Manual flash less intimidating. To utilize Manual flash mode, the EOS camera should be set to M (Manual) or to Av (Aperture-Priority

AE) operating mode. Set the camera to Manual mode if you want control over both the shutter speed and aperture. Changing the shutter speed in Manual mode adjusts background exposure. However, the shutter speed selected must be no faster than the camera's appropriate flash sync speed. For simplicity's sake, first try setting it to Av mode.

Note: Here's why we suggest Av or Manual mode: If Shutter-Priority AE (Tv) mode is selected, flash exposure will be inaccurate. If one of the Program modes or Full Auto mode is selected, the Speedlite automatically switches to non-manual, fully automatic A-TTL operation. If a "wrong" operating mode is set on the camera, the minimum aperture of the lens in use blinks in the camera's LCD panel when the shutter button is depressed halfway.

In Aperture-Priority mode you set the f/stop, and the camera automatically sets the fastest possible sync speed, which will remain constant. In this case, the aperture selection determines the flash exposure. Now proceed with the following sequence:

1. Set the 540EZ to Manual flash mode by pressing the MODE button. "M" will appear on the flash unit's LCD panel.
2. Press the SEL/SET button on the back of the flash head. A blinking "1/1" symbol will appear; this indicates that the full power level has been set.
3. For this exercise, set the power level to 1/8 by pressing the + or – button on the back of the flash until the flash's LCD panel reads "1/8."
4. Press the SEL/SET button to stop the power output level from blinking, or wait eight seconds for it to stop automatically.
5. Locate the subject in the viewfinder and center it in the frame. Press the shutter release button to activate autofocus and exposure metering.
6. Now check the focused subject distance indicated on the lens' distance scale.
7. Check the coupling range distance scale on the back of the 540EZ; a small bar will indicate a certain narrow distance range. This will differ depending on the aperture selected, lighting conditions, film speed, etc.

8. The key to "accurate" exposure is to match the subject distance with the distance denoted on the 540EZ's distance range scale. If the two do not coincide, change the aperture (f/stop) on the camera or move closer to or farther away from the subject.

Note: If there is a discrepancy between the flash range and the subject distance, change the flash power. This should allow you to shoot from the desired distance and aperture—f/4 for limited depth of field or f/16 for extensive depth of field, for example. If the two distances now do not match exactly, change the lens aperture (f/stop) until the distance values coincide. Or if the combination is not what you need and the shot is important, consider changing to a faster or slower film.

9. Check the distance indicator bar on the back of the flash again to see that it coincides with the actual subject distance.
10. Check to see that the shutter speed and aperture displays in the viewfinder are not blinking.
11. Wait until the flash-ready symbol is lit, and press the shutter release button to take the photo. The flash exposure should be accurate as long as the subject is at the distance indicated.

Caution: When shooting a series of photographs in Manual flash mode, the flash can become overheated. Limit the number of continuous flashes according to the power setting as follows:
a) 1/1 and 1/2 power: no more than 15 consecutive flashes
b) 1/4 and 1/8 power: no more than 20 consecutive flashes
c) 1/16 and 1/32 power: no more than 40 consecutive flashes.

Hint: An accessory light meter, such as the Polaris™ digital flash meter, can be used for more precise exposure control. It is also handy to have one on hand for emergencies, and they are available through The Saunders Group (address on back cover).

For more information on using a specific EOS model in Av or M mode, refer to the *Magic Lantern Guide* on your particular camera.

Stroboscopic Flash Mode

The 540EZ offers a Stroboscopic or "MULTI" mode, which fires flash several times in succession, recording several sequential images of a moving subject on a single frame of film. The 540EZ can fire up to 100 flashes during a single exposure in this mode.

This feature offers the photographer a wide range of creative opportunities. Phases of motion that are otherwise invisible to the naked eye are frozen on a single frame of film. This is quite an accomplishment for a small flash unit, considering what used to be required to produce this result not too long ago. In the past, photos like this required complicated experimental setups involving the use of several flash units. The Speedlite 540EZ and an EOS camera put strobe flash shots within reach of any photographer—pro or amateur. Although many photographers never actually use this feature, it can be fun and educational. We encourage you to experiment with this technique.

Controlling Stroboscopic Flash

In Stroboscopic (MULTI) mode, three factors can be controlled: the firing frequency, the number of bursts emitted, and the power output level of the flash. On the 540EZ, pressing the SEL/SET button accesses each of these functions in turn. The value of each can be changed by pressing the sync timing (+ or –) buttons while the factor in question is blinking on the LCD panel.

Firing frequency: The stroboscopic firing frequency is measured in the number of flashes per second, or Hz (hertz). Firing frequency can be set within a range of 1 Hz to 100 Hz. (In 1 Hz increments between 1Hz and 20 Hz; in 5 Hz increments between 20 Hz and 50 Hz; and in 10 Hz increments from 50 Hz to a maximum of 100 Hz.)

Number of bursts and power output level: Up to 100 continuous bursts (100 Hz) are possible during a single exposure in the 540EZ's Manual flash mode. The actual number depends on the power output level and the firing frequency selected. The 540EZ will emit as many bursts as possible during the exposure time at the power level selected. Strobe flash is not possible at the 1/1 and 1/2 power settings.

Note: Successful stroboscopic flash requires the use of fresh alkaline batteries or lithium AAs. Even better, to avoid having to change batteries constantly, use one of the external power supply sources described in the *Speedlite Accessories* chapter.

Stabilizing the camera: In Stroboscopic mode, a longer-than-normal shutter speed should be selected to allow sufficient time to record subject movement. Since this may mean a shutter speed of one second or more, a tripod is recommended to prevent recording the effects of camera shake. A remote switch (electronic cable release), such as Canon's 60T3, is also useful for triggering the camera without creating vibration.

Setting the Flash Unit for Strobe Flash

1. After turning the camera and the 540EZ on, press the flash unit's MODE button until "MULTI" is displayed on the flash unit's LCD panel.
2. Press the SEL/SET button to select one of the three stroboscopic flash variables: Firing Frequency (Hz), Number of Bursts, or Power Level. The active variable blinks in the display. When the SEL/SET button is pressed a fourth time, the blinking stops and the entire LCD display is lit, showing what settings have been selected.
3. First, the flash frequency (Hz) blinks on the LCD. Select the desired frequency using the + or – button.

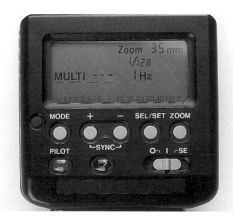

To activate Strobe mode, press the MODE button until MULTI appears on the LCD panel. Use the SEL/SET button and the + and – buttons to enter the frequency, number of bursts, and power level.

4. Pressing the SEL/SET key again stops the Hz numeral from blinking, confirming the frequency setting. The numeral representing the number of bursts now blinks.
5. Press the + or − button to set the desired number of bursts.
6. When the SEL/SET button is pressed again, the number of bursts stops blinking and the power output level numeral blinks. Use the + or − button to set a power level.
7. Press the SEL/SET button to stop the variables from blinking, or you can wait eight seconds for all blinking to stop automatically.

Setting the Camera for Strobe Flash
First set the EOS camera to Manual (M) exposure mode and select the desired aperture (f/stop).

Select a shutter speed that is long enough for all the strobe bursts to be emitted. For example, 20 bursts at 20Hz will require one full second. Select a longer shutter speed to build in a margin of safety. The correct shutter speed can be determined using the following formula:

Shutter Speed = Number of Bursts ÷ Flash Frequency (Hz)

For example, 8 flashes at 10 Hz would be 8/10 = 0.8 second. Therefore you should round up the exposure time to at least one second. In order to be 100% sure that you get the exposure you want, double the exposure time to a shutter speed of two seconds.

If the desired number of bursts is set to "- -", signifying that no number was selected, the Speedlite 540EZ will keep firing until the shutter closes or the flash charge is depleted. The flash unit will fire the maximum number of bursts listed in the chart below, regardless of the firing frequency selected.

Flash Output Level	1/4	1/8	1/16	1/32	1/64	1/128
Maximum No. of Bursts	15	20	50	70	100	160

Note: Stroboscopic flash is possible only in the 1/4 to 1/128 power level range. It will not operate if 1/1 or 1/2 is selected.

Now focus on the subject by aiming the active focusing point at the subject and pressing the shutter release partway.

To determine correct flash exposure, follow the procedure outlined in the "Flash with Manual Exposure Mode" section of the previous chapter. That will give you a good place to start. However, sometimes the flash bursts create overlapping exposures in some areas of the image. If this is not taken into account, overexposure can occur. To avoid overexposing overlapping images, you can reduce the aperture or increase the distance of the flash to the subject. It is always wise to make some test shots or bracket exposures to ensure good results.

Once appropriate exposure values have been set, check the LCD panel on the 540EZ to make sure the subject distance coincides with the flash's coupling range distance scale. If not, set a different aperture or change your position. Background exposure is determined by the shutter speed selected. Check the warning symbol in the camera's viewfinder: a plus (+) warning indicates the background will be overexposed, while a minus (–) warning indicates it will be underexposed. You may not want "correct" background exposure or you may want to bracket background exposure from one frame to the next. Learn by experimenting.

When the flash ready indicator (lightning bolt) appears in the viewfinder, the shutter release can be depressed fully to take the picture.

Note: Stroboscopic flash can also be used with long time exposures (with the camera set for Bulb in Manual mode). The best results are obtained with a moving subject that is bright and highly reflective, positioned in front of a dark background. This allows the motion phases to be clearly differentiated from the background. The dark surface should reflect as little light as possible; a black velvet cloth is ideal.

Maximum Number of Continuous Flash Bursts

With the following chart, you can determine the maximum number of bursts possible with the 540EZ at any combination of power output level and frequency (Hz). For instance, at 1/32 power and 14 flashes per second, the maximum number of bursts is 20. The 540EZ will not allow you to set a combination that is beyond its capability.

Output Level \ Hz	1	2	3	4	5	6	7	8	9	10
1/4	7	6	5	4	4	3	3	3	3	2
1/8	14	14	12	10	8	6	6	5	5	4
1/16	30	30	30	20	20	20	20	10	10	8
1/32	60	60	60	50	50	40	40	30	30	20
1/64	90	90	90	80	80	70	70	60	60	50
1/128	100	100	100	100	100	90	90	80	80	70

Output Level \ Hz	11	12	13	14	15	16	17	18	19	20
1/4	2	2	2	2	2	2	2	2	2	2
1/8	4	4	4	4	4	4	4	4	4	4
1/16	8	8	8	8	8	8	8	8	8	8
1/32	20	20	20	20	18	18	18	18	18	13
1/64	40	40	40	40	35	35	35	35	35	30
1/128	70	70	70	70	50	50	50	50	50	40

Output Level \ Hz	25	30	35	40	45	50	60	70	80	90	100
1/4	2	2	2	2	2	2	2	2	2	2	2
1/8	4	4	4	4	4	4	4	4	4	4	4
1/16	8	8	8	8	8	8	8	8	8	8	8
1/32	16	16	16	16	16	16	12	12	12	12	12
1/64	30	30	30	30	30	30	20	20	20	20	20
1/128	40	40	40	40	40	40	40	40	40	40	40

Multiple-Flash Photography

A single flash unit, even if it is the Speedlite 540EZ with its wide range of features, has certain limitations to achieving a photo that appears to be lit naturally. While the subject can be lit effectively, it is difficult to control the background and surrounding shadows.

When several flash units are positioned appropriately and at different angles, more balanced, three-dimensional lighting effects can be achieved.

With Canon's multiple-flash accessories, TTL flash control is maintained, eliminating the need for complex exposure calculations. All Canon Series E, EX, and EZ Speedlites, as well as the 480EG grip-type model and the Macro Ring Lite ML-3 can be used in multiple-flash setups, with a maximum of four flash units operated simultaneously. See the *Speedlite Accessories* chapter for further information.

The Multiple-Flash Setup
A typical multi-flash setup might look like this: One flash unit is attached to the EOS camera's hot shoe via a TTL Hot Shoe Adapter 3. A Connecting Cord runs from the Hot Shoe Adapter 3 to the Canon TTL Distributor accessory, which can accept three Connecting Cords that lead to additional Speedlites. Each of these remote units is attached to the cord via an Off-Camera Shoe Adapter.

Hint: When setting up a multiple-flash configuration, you may find that you need a longer connecting cable than you have available. It is possible to link up to three Connecting Cords together and create a total length of 30 feet (9 meters).

Shooting with multiple flash units is really very easy. All you need to do is connect the flash units with appropriate Canon-compatible accessories, and on each individual unit make sure that the ready (PILOT) lamp is lit and that the flash mode is set to A-TTL* or TTL. Then simply trip the shutter to make the exposure. The exposure confirmation lamp (on the 540EZ only) will light to confirm if adequate TTL flash exposure was produced.

Note: In multi-flash setups, A-TTL mode does not operate (though if it is set, it is displayed in the flash unit's LCD panel). The system defaults automatically to TTL flash control because the pre-flash information gained from more than one flash (in A-TTL mode) would conflict.

Manual flash and Stroboscopic flash operation are both possible in multiple-flash setups.

Multiple-Flash Setup

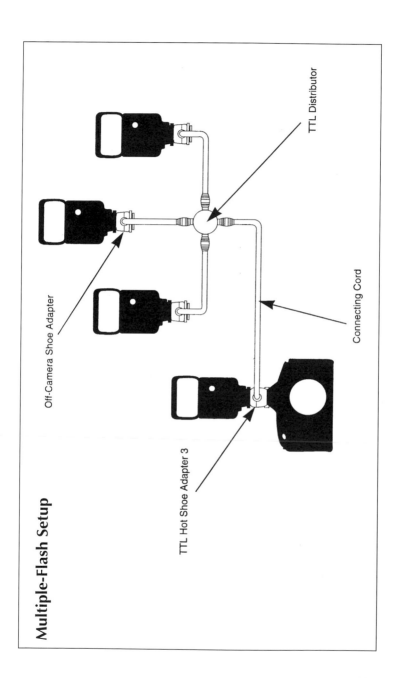

TTL Distributor

Connecting Cord

Off-Camera Shoe Adapter

TTL Hot Shoe Adapter 3

Caution: If the battery in the TTL Hot Shoe Adapter 3 becomes depleted, the flash-ready status cannot be transmitted to the flash unit and the flash unit will not fire. Always check the adapter's battery level before use. (See page 155.)

Adjusting Lighting Ratios

In multiple-flash setups, all connected Speedlites will fire and cease firing simultaneously. If you set flash exposure compensation on the camera (using an EOS-1N/RS or an EOS-A2/A2E), the value will be identical for all Speedlites. However, given those restrictions, there are several methods for controlling the lighting ratio—the relative brightness of any of the Speedlites in relation to any of the others.

As mentioned earlier, the farther a flash unit is located from the subject the less light is received. Doubling the distance reduces light to about one-quarter of the original amount. Therefore, the Speedlite closest to the subject will provide the most light while the unit farthest away will provide the least amount. Adjust the location of each unit accordingly.

When the zoom head of a 540EZ is set at 105mm, it produces approximately 2 stops more light than at the 24mm setting. With a

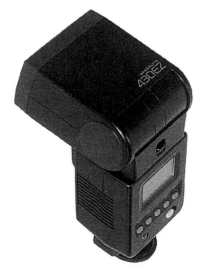

The Speedlite 430EZ features A-TTL control, auto-zoom capability with six focal length settings (plus manual override), stroboscopic mode, and second-curtain sync. It's perfect for use in multi-flash setups.

430EZ the difference between the 24mm setting and the 80mm setting is 1.5 stops. Pulling the diffuser panel into place further reduces light output. Adjusting the zoom head of each Speedlite will increase or decrease the amount of light that the unit will provide. As long as you can compose the scene so the subject is within the coverage angle of each Speedlite, the zoom head setting can be used to control flash ratio.

When a diffuser accessory, neutral density filter, or tracing paper is attached over the flash reflector, the amount of light is diminished. And when a Speedlite is set for bounce flash, less light reaches the subject than those set for direct flash. Use one or more of these tactics on one or two Speedlites for ratio control.

The above techniques involve TTL flash exposure control, which produces accurate results without calculations. With the 540EZ and/or the 430EZ Speedlites in Manual (non-TTL) flash mode, ratio control is possible, although the calculations become complicated. Settings range from full power (1/1) to 1/32 power with a 430EZ and to a very low 1/128 power with a 540EZ. This allows for direct lighting ratio control. We recommend using an accessory flash meter to determine the aperture that should be set on the camera when using Manual flash mode.

540EZ Functions in Multiple-Flash Use

540EZ Function	Normal Flash Operation	Multi-Flash Operation
Automatic A-TTL control	Yes	No*
A-TTL infrared pre-flash	Yes	No
Automatic TTL control	Yes	Yes
Flash coupling range display	Yes	No
Flash exposure confirmation	Yes	Yes
Exposure compensation by 540EZ	Yes	No**
Manual flash output level control	Yes	Yes
Strobe flash	Yes	Yes
Second-curtain sync	Yes	No†
Automatic zoom	Yes	No††
AF auxiliary light	Yes	No
SE (Save Energy) mode	Yes	Yes

* Even if A-TTL appears on any of the Speedlites' LCD panel, the flash will operate in TTL mode. (This occurs because the pre-flash information would be contradictory from more than one flash.)

** If flash exposure compensation is set on a Speedlite, the compensation factor appears on the LCD panel, but flash compensation *will not occur.* When shooting with multiple flash units, compensation corrections must be implemented using settings on the camera. The EOS-1N/1N RS, EOS-A2/A2E, and EOS Elan II/IIE include a flash compensation function that can control accessory Speedlites. Other EOS cameras with this feature can control only the built-in flash unit.

† If second-curtain sync is set, the symbol will appear on the LCD panel, however it will actually operate only in first-curtain sync.

†† Although automatic zooming of the flash heads is disabled, it is possible to set the flash units' zoom positions manually. The flash coupling range distance scale on the LCD panel of a 540EZ or 430EZ are not displayed in TTL or Manual flash modes.

The Speedlite 430EZ

The Speedlite 430EZ was an extremely popular model with many of the same features as the 540EZ, including TTL and A-TTL flash control, a swiveling flash head, the ability to be used for direct or bounce flash, Rapid Fire flash, stroboscopic flash, motorized zoom control, and second-curtain sync. Therefore many of the techniques described in this book that pertain to the 540EZ are applicable to the 430EZ as well. The controls differ somewhat, but all are well marked. Its guide number of 141 in feet (43 in meters) at ISO 100 and at 80mm is lower than that of the 540EZ, and some of the high-tech functions that the 540EZ offers are missing or less versatile on the 430EZ.

The 430EZ is an extremely useful model that would make a fine backup to the 540EZ. Two Speedlite 540EZs and a 430EZ (or a

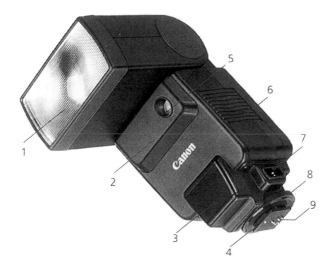

1.	Flash head	6.	Battery chamber
2.	Infrared light emitter	7.	External battery pack socket
3.	AF auxiliary light emitter	8.	Lock wheel
4.	Lock pin	9.	Direct-coupled contacts
5.	Pre-flash sensor		

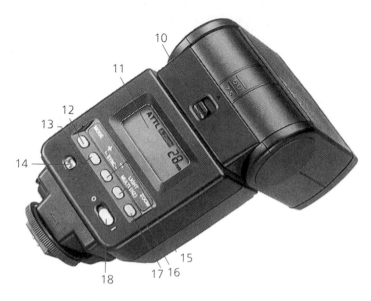

10. Bounce latch	15. Minus (–) button
11. Display panel	16. LCD illumination/Strobe frequency button
12. A-TTL/Manual/Rapid Fire Flash button	17. Zoom button
13. Plus (+) button	18. Main switch
14. Ready lamp/Test firing button	

third 540EZ) can comprise a flash system rivaling a studio setup. Add some of the non-Canon accessories (such as diffusion, "soft box," or bounce accessories) mentioned elsewhere in this guide, and the results can be exceptional.

Speedlite 430EZ Specifications

Type: Automatic electronic flash unit with A-TTL flash metering, which measures light reflected off the film plane. Clip-on style flash unit with direct-coupled contacts.

Guide number: Varies depending on zoom head setting. All guide numbers given are at ISO 100: 24mm, 82 in feet (25 in meters);

28mm, 89 in feet (27 in meters); 35mm, 100 in feet (30 in meters); 50mm, 116 in feet (35 in meters); 70mm, 132 in feet (40 in meters); and at 80mm, 141 in feet (43 in meters).

Battery life and recycle time: Using four AA alkaline batteries, it will produce approximately 100 to 700 bursts recycling at between 0.2 and 13 seconds; with NiCd batteries, 45 to 300 bursts recycling at between 0.2 and 6.5 seconds. The flash unit recycles in Rapid Fire mode with alkaline batteries loaded from 0.2 to 1.5 seconds, with NiCd batteries, from 0.2 to 1.0 second.

Flash duration: 1.5 milliseconds or less.

Coverage angle: Internal zoom-head setting automatically matches the focal length of the lens in use at 24mm, 28mm, 35mm, 50mm, 70mm, and 80mm. Manual zoom-head setting also possible.

Flash exposure modes: A-TTL, TTL, variable-power Manual, stroboscopic (up to 10 flashes per second), and second-curtain sync modes (available in all exposure modes except Program and Depth-of-Field AE).

Flash head settings: A maximum rotation angle of 90° upward, swivels 0° to 180° to the left; swivels 0° to 90° to the right.

Flash exposure level control: Automatic exposure control from 0 to –1.5 EV based on ambient light; manual control from +3 to –3 EV in 1/3-stop increments.

Flash metering system: Measures light reflected off the film plane. A-TTL automatic flash with test pre-flash, TTL automatic flash metering (in Manual exposure mode), Manual flash mode also available.

Flash exposure compensation: Possible with all EOS cameras *except* the EOS 620, 650, 700, 750, and 850 camera models.

Flash coupling range (with a 50mm f/1.8 lens and ISO 100): In A-TTL full-power flash mode, 2.3 to 62.3 feet (0.7 to 19 meters). Rapid Fire Flash from 2.3 minimum to 45.9 feet maximum (0.7 to 14 meters).

Fastest flash sync speed: 1/90 second with the EOS Rebel (1000), EOS Rebel II (1000N), and EOS Rebel X (500); 1/125 second with the EOS 630 (600), 650, 700, 750, 850, EOS RT, EOS 10S (10), EOS Elan (100), and EOS Elan II/IIE (EOS 50/50E); 1/200 second with the EOS A2/A2E (5); and 1/250 second with the EOS-1N/1N RS, depending on the camera model in use.

Flash ready indicator: When the ready light is green, Rapid Fire Flash is possible (at partial power); when it is red the flash unit is fully charged. When an external battery pack is used the ready lamp lights red.

AF auxiliary light: In low light, the flash unit projects a pattern of red light onto the subject in order to give the autofocus system a target to focus on.

Power sources: Four AA alkaline or NiCd rechargeable batteries.

External power sources: Transistor Pack E and the Compact Battery Pack E.

Save-energy function: Automatically active when main switch is turned on. After 90 seconds of non-use the flash unit automatically shuts off.

Mode memory: All current flash settings are held in memory when flash unit is turned off.

Warning signals: Upon pressing the EOS camera's shutter release partway, the distance scale blinks if the subject is too close to the camera. With the EOS-1, EOS 620, 630, 650, and EOS RT, the aperture and shutter speed blink if the subject is outside of the flash unit's range (too far away).

Dimensions (w x h x d): 2-15/16″ x 4-13/16″ x 4-3/16″ (75 mm x 122 mm x 106 mm).

Weight (without batteries): 12.7 oz. (365 g).

The Speedlite 380EX

Canon's Speedlite 380EX, introduced at the same time as the EOS Elan II/IIE (EOS 50/50E), offers advanced features not available with other Speedlites. Its advanced features, E-TTL (Evaluative Through-the-Lens) flash mode, FP (Focal Plane) flash, and FE (Flash Exposure) lock, function only with the EOS Elan II/IIE (EOS 50/50E) at the time of this writing. The 380EX can, of course, be used as a TTL autofocus zoom flash unit with other EOS models.

The 380EX also offers flash exposure compensation, auto flash exposure with manual shutter speed and aperture settings, second-curtain sync, and multiple-flash compatibility. These features function with all EOS cameras (if there are limitations and restrictions, they are noted in corresponding sections). The Speedlite 380EX is compatible with most Canon flash accessories except the external power packs. See the *Speedlite Accessories* chapter for more information.

Speedlite 380EX

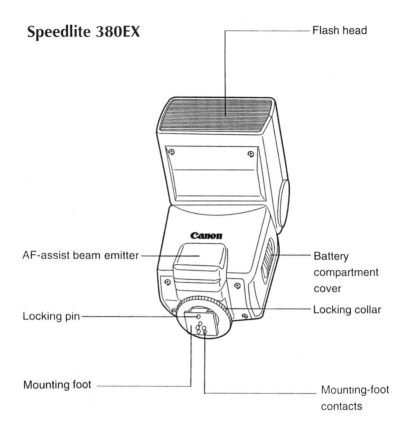

Flash head

AF-assist beam emitter

Locking pin

Mounting foot

Battery compartment cover

Locking collar

Mounting-foot contacts

380EX Operating Instructions

Battery Information

The 380EX can be powered by four AA alkaline (LR6 or AM-3) batteries, which provide 260 to 1,800 flashes at recycling times of 0.1 to 7.5 seconds. You can attain slightly faster recycling times of 0.1 to 4.5 seconds if four AA NiCd (KR15 or KR51) batteries are installed, but they produce only 75 to 500 flashes per charge. Although some flash units can be harmed by the higher initial voltage of lithium batteries, the 380EX has been designed to compensate for this fluctuation and Canon has approved the use of AA lithium (FR6) cells with this flash unit. Lithium batteries offer both high voltage and long life—terrific assets in a power source.

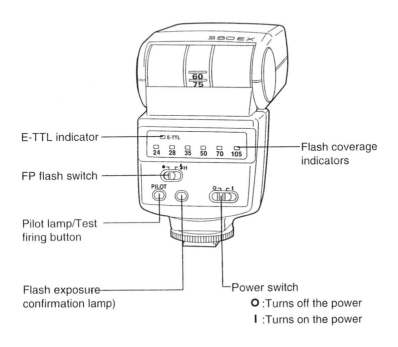

E-TTL indicator

Flash coverage indicators

FP flash switch

Pilot lamp/Test firing button

Flash exposure confirmation lamp)

Power switch

O :Turns off the power

I :Turns on the power

Note: The Speedlite 380EX cannot be used with an external power source.

To install the batteries, slide the battery compartment cover to the right and flip it up. Make sure that the metal contacts inside the battery compartment are clean and free of corrosion or oxidation (if in doubt, gently clean them with a tissue or pencil eraser). Insert four identical, new batteries as indicated on the inside of the battery compartment. Flip the cover down and slide it back to its original position.

Mounting the Speedlite 380EX to an EOS Camera

The Speedlite 380EX is an EOS-dedicated flash unit, which can be mounted to any EOS camera.

First loosen the Speedlite's locking collar (the knurled wheel at the base of the unit). Slide the flash's foot onto the camera's hot shoe completely. Tighten down the locking collar by turning it clockwise until it is snug. This will seat the foot's locking pin into the camera's hot shoe.

To remove the flash unit from the camera, turn the locking collar counterclockwise until it stops. This retracts the locking pin back into the flash unit. Slide the Speedlite out of the hot shoe.

Note: The 380EX can be mounted securely to the EOS 620, 650, 750, and 850 cameras although their hot shoes do not have a locking pin hole.

On/Off Switch

The 380EX's on/off switch is labeled "I" for on and "O" for off. If the Speedlite is switched on, a power-saving feature turns the unit off after 90 seconds of inactivity. To reactivate the flash unit, press the camera's shutter release or the flash unit's pilot lamp/test firing button.

Pilot Lamp/Test Firing Button

The pilot lamp illuminates red when the flash is fully charged and ready for exposure. It can be pressed to test fire the flash unit.

Note: The flash cannot be fired or tested while the shutter release is pressed halfway down or during the four seconds that elapse after the shutter has been released.

Flash Exposure Confirmation Light

The flash exposure confirmation light illuminates for two seconds after the exposure has been made if flash exposure was sufficient. If this light does not illuminate, the light given off by the flash was insufficient for adequate exposure. In this situation, move closer to

This flower, a red hot poker, was blooming by the side of the road. The ⇨
daylight was dim at the time, so a Speedlite was placed to the side of the
flower (with the aid of an Off-Camera Shoe Cord 2), which served to
emphasize the flower's brilliant color.

Fill flash was used to define the texture and bring out the color of these lupines.

The richness of the color in these photos is due to the use of flash. One stop of minus (–) flash exposure compensation was set, allowing the sunlight to remain the main light source. This strategy produced a more natural-looking effect. Photos by Peter K. Burian.

This small doll from Schleswig-Holstein, Germany, is wearing one of the region's traditional costumes. Use of the Macro Ring Lite ML-3 created a somewhat flat illumination, making it possible to capture the doll's rather sad expression.

Thanks to the Macro Ring Lite ML-3's shadowless illumination, most of this doll's intricate details can be seen despite the shallow depth of field.

Top left:
Off-camera flash offers a broad range of possibilities. In this photo, the Speedlite 540EZ was connected to the camera using the Off-Camera Shoe Cord 2 and placed to the side of the subject. It gives the subject an air of intrigue.

Left:
The 540EZ was again used with the Off-Camera Shoe Cord 2, but this time fired sideways toward a reflective surface. The resulting illumination is softer than with direct sidelighting (above).

Top right:
Here, the flash was positioned below the subject, producing a ghoulish lighting effect.

The shadows created by flash are barely noticeable on a dark background (top left). Indirect flash softens the light (top right). Using the wide-angle diffusion panel with the flash head tilted upward creates catchlights in the eyes (right). The two bottom photos were taken without the wide-angle diffusion panel. The left with direct flash and the right with indirect flash.

your subject, change to a more sensitive film, or set plus exposure compensation on the camera and then take another exposure.

FP Flash Switch

This switch is used to select normal or high-speed sync. Select the dot (•) for normal flash sync and the lightning bolt followed by an "H" for high-speed (FP) sync. FP sync is possible with the EOS Elan II (EOS 50) series cameras. See page 135 for more information.

AF Assist Beam

If the scene has insufficient light or contrast, the 380EX has an AF assist beam that helps the camera autofocus. Its range is from 2.3 to 33 feet (0.7 to 10 meters). The 380EX's AF assist beam is linked to the camera's central focusing point and will fire when any EOS camera's central focusing point is active.

If, however, the 380EX is used with an EOS camera with multiple focusing points, such as the Elan II/IIE or EOS-1N, the AF assist beams in the flash unit and camera work together. If the central AF point is active, the flash unit's beam is engaged. If one of the outer focusing points is active, the camera's AF assist beam engages instead.

Flash Exposure Compensation

Flash exposure compensation can be set with the 380EX when it is mounted to an EOS-1N/1N RS, EOS Elan II/IIE (EOS 50/50E), or an EOS A2/A2E (EOS 5) camera. Because each camera is different in this capacity, refer to the camera's instruction manual for guidance on how to set this feature.

Bounce Flash

The 380EX Speedlite's reflector head can be tilted up to 90° to bounce light off a ceiling or wall. (The Speedlites 420EZ, 430EZ, 480EG, and 540EZ also have this feature.) Redirecting the light's path diffuses the light, reducing the potential for hot spots and hard shadows that can result from direct flash. When the Speedlite 380EX is used for bounce flash, E-TTL flash control is maintained.

◁ **This photo benefited from the use of fill flash. Without it, the colors of this still life would not have been so rich. Photo by Peter K. Burian.**

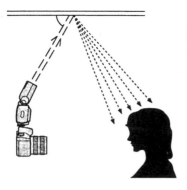

Bouncing flash off a wall or ceiling diffuses the light and reduces the harsh glare often resulting from direct flash illumination.

By tilting the flash head up toward the ceiling, a large, soft, light source is created. The light travels to the ceiling, becomes diffused, and then is reflected down onto the subject. This soft light produces a far more natural effect than direct flash, and red-eye is generally eliminated. However, because the light is projected from above, sometimes shadows can appear under subjects' eyes. This can be avoided somewhat by changing the angle of the flash head, thus affecting the angle at which the light source meets the subject.

Hint: Make sure that the bounce surface is white (or neutral), and without texture or pattern (as with wallpaper). If not, the light will reflect the color and pattern of the bounce surface onto the subject. However, this can be used to your benefit. By bouncing the normally cool-toned light from the flash onto a warm-toned or cream-colored wall or ceiling, you can produce a warmer glow instead of the cooler effect produced by unadulterated flash light.

Remember that light must travel much farther for a bounce flash exposure than direct flash. Because of the increased distance, the light becomes diffused and up to two stops of light can be lost. As a result, you may need to open up the aperture, use a slower sync speed (with a tripod), or use a more sensitive film. If you are shooting in a large room with a high ceiling or dark walls, bounce flash is not an option. Consider using two flash units to produce indirect lighting.

Auto Zoom

The 380EX's flash head not only tilts for bounce flash, but also zooms automatically to match the focal length of the lens in use (or the focal length that a mounted zoom lens is set at). The flash head can zoom to cover 24mm, 28mm, 35mm, 50mm, 70mm, and 105mm focal lengths. The current angle of coverage is displayed on the back of the flash unit when the shutter release is pressed partway (a light illuminates above the setting corresponding to the lens' focal length).

As the angle of flash coverage changes, the guide number also changes. The shorter the lens, the wider the angle of illumination, however the maximum distance the light can travel is reduced. Likewise, the longer the lens, the more concentrated the light is over a narrower angle of view, and therefore, the farther the light can travel. With ISO 100 film, the flash unit's guide number ranges from 69 in feet (21 in meters) at its 24mm setting to 125 in feet (38 in meters) at its 105 mm setting.

The shortest setting (24mm) fully illuminates the image field of a 24mm wide-angle lens. If a wider-angle (shorter) lens is used, the light will fall off or dissipate toward the edges of the image. At the other end of the scale, if you use a lens longer than 105mm, the flash unit's guide number will not increase any more than 125 in feet, because the flash is not physically able to narrow its range any further. Hence, the distance the light can travel cannot increase. With a very long lens, the light fall-off may be so great that insufficient exposure may result. If that is the case, the flash exposure confirmation lamp will not blink to confirm adequate exposure.

Multiple Flash

Once you have mastered the use of a single flash, you may want to explore the variety of effects that can be achieved with multiple flash units. Canon has a complete line of adapters and distributors to link flash units together, all of which are compatible with the 380EX. With the 380EX as the main flash unit, you can take advantage of its TTL auto flash feature while connecting up to four Canon Speedlites. Compatible Speedlites include the 480EG, any EZ-series Speedlite, and the Macro Ring Lite ML-3. One word of caution, however: Before making an exposure with a multiple flash system, double check that the pilot lights are lit on every Speedlite that's connected.

380EX Advanced Features

At the time of publication, the advanced features of the 380EX can be used only with the EOS Elan II/IIE (EOS 50/50E).

E-TTL Flash

E-TTL (Evaluative Through-the-Lens) flash control refers to the Elan II/IIE's six-zone evaluative metering system, which is used to coordinate flash and ambient light for automatic flash exposure control. It is the first system to employ such a system.

The E-TTL system is very different from the A-TTL and TTL automatic flash control systems employed by the EOS camera's built-in flash and other Speedlite flash units. Those flash units tie into the camera's four-point, three-zone internal metering sensor, which reads light reflected off the film plane. Although these systems are excellent, E-TTL goes one step further in the quest for accurate flash exposure. E-TTL does not take readings off the film plane, but instead uses the Elan II/IIE's six-zone evaluative metering system for more precise and better-balanced exposures.

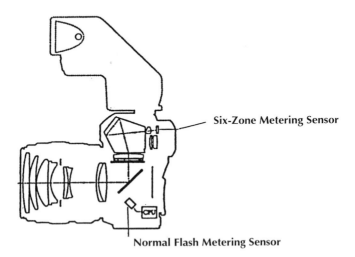

Six-Zone Metering Sensor

Normal Flash Metering Sensor

When the Speedlite 380EX is mounted to the Elan II/IIE (EOS 50/50E) and is in E-TTL flash mode, the Elan's six-zone exposure metering sensor determines the flash exposure.

Here's how it works: The Elan II/IIE's AIM (Advanced Integrated Multi-Point) system links metering and flash exposure readings to the camera's active focusing point. When the camera's active focusing point (in red) is aimed at the subject and the shutter release is pressed partway, the Elan II/IIE autofocuses and measures the ambient light with its six-zone evaluative metering system. From these readings, the shutter speed and aperture settings are determined. The 380EX then fires a pre-flash, which bounces off the subject and back to the camera's six-zone sensor. By comparing the relationship between the ambient and flash light, the camera's evaluative metering system determines the appropriate flash output to produce correct exposure.

The E-TTL system differs from the A-TTL system in that it measures the reflectivity of the subject and its distance away from the flash unit. As mentioned previously, the Elan II/IIE's six-zone sensor does not measure light reflected off the film plane, and hence the reflectivity of the film does not influence its readings. Hence, the subject and background exposure are evaluated more precisely. Regardless of where the subject is located within the image frame, E-TTL produces a natural-looking exposure.

Shooting in E-TTL Mode
Taking flash exposures with E-TTL flash control requires no more effort from the photographer than conventional flash metering systems. Simply set the Elan II/IIE's command dial to any mode (other than Landscape, Sports, or Depth-of-Field AE), turn on the 380EX's main switch, and slide the FP flash switch to the green dot (indicating normal flash mode). When the shutter release is pressed partway, the camera sets autofocus on the subject within the active focusing point, and the E-TTL sequence begins. The shutter speed, aperture, and flash ready symbol (lightning bolt) appear in the viewfinder, and a pre-flash is emitted. Finally, push the shutter release down all the way to make the exposure. E-TTL flash metering almost always produces flash exposures that are technically accurate and appropriately balanced with the ambient light.

FP Flash (High-Speed Sync)
The 380EX offers FP (Focal Plane, or high-speed sync) flash mode, which allows you to select a shutter speed faster than the

Elan II/IIE's normal top sync speed of 1/125 second in Program AE, Shutter-Priority AE, Aperture-Priority AE, Manual, and Depth-of-Field AE modes. When the flash unit's FP flash switch is set to FP mode (a lightning bolt and an "H"), FP flash mode will automatically engage if a shutter speed faster than 1/125 second is selected. This is one of the 380EX's advanced features that operates only with the Elan II/IIE (EOS 50/50E) at the time of publication.

FP flash mode is invaluable when fast shutter speeds are crucial to achieving the desired effect. If you are shooting sports or action, it eliminates the chance of recording ghost images of the subject recorded from ambient light. You can also use FP mode for fill flash to eliminate harsh shadows when taking portraits in bright daylight, or when you are using a fast shutter speed and wide aperture to blur the background. When shooting outdoors with a fast shutter speed, FP flash can be used to create catchlights in the subject's eyes as well.

A camera's fastest normal sync speed is determined by the shortest amount of time during which the shutter curtains are completely open, revealing the entire frame of film at once. With normal flash, one single burst of flash light fires during that interval. (Hence the term "flash synchronization speed.") Any shutter speed faster than this reveals only a portion of the frame at any given moment, as one curtain chases the other across the film frame. In FP mode, the 380EX produces a series of flash bursts during the time that the shutter curtain travels across the film frame. If a single burst of flash were fired with the Elan II/IIE set to a shutter speed faster than its normal top sync speed (1/125 second), only a narrow portion of the image area would be exposed. But with a series of stroboscopic bursts, the entire image can be recorded on the film frame.

Because producing many flash bursts requires more energy than producing a single burst of flash, FP mode results in a lower guide number and a reduced range. Using ISO 100 film and a 35mm lens, at 1/180 second the guide number is 49 in feet (15 in meters), nearly half that of using normal flash at 1/125 or slower sync speed with the same lens. At 1/4000 second with the same lens and film, the guide number is merely 11.5 in feet (3.5 in meters). The maximum range of the flash also varies with speed of the lens. The range is reduced when slower lenses and/or faster shutter speeds are used.

To take a picture in FP mode, first set the camera's exposure mode to P, Tv, Av, M, or DEP. Depending upon the exposure mode you have chosen, set the appropriate user-controlled aperture and/or shutter speed settings. Set the FP flash switch of the 380EX to the high-speed position (a lightning bolt and an "H"). The identical symbol will appear in the camera's viewfinder. If nothing blinks in the viewfinder, it is safe to take the picture. Simply press the shutter release.

Note: If the shutter speed selected on the EOS Elan II/IIE (EOS 50/50E) is 1/125 or slower and the 380EX is set to FP mode, the flash unit will default to normal flash sync mode. If any other EOS model camera is used and the 380EX is switched to FP mode, FP mode will not operate. The flash will operate in normal flash sync mode.

FE Lock
Although in most situations E-TTL flash produces highly accurate results, sometimes you may want to lock flash exposure readings on one particular portion of the image (a portion not covered by one of the focusing points, for instance). The 380EX allows you to use the camera's FE lock button to ensure correct flash exposure of the selected subject. FE lock is available in the Elan II/IIE's Program AE, Shutter-Priority AE, Aperture-Priority AE, Depth-of-Field AE, or Manual modes.

To take advantage of the FE lock feature, aim the camera's central focusing point at the subject you wish to have the camera take a meter reading from. Press the shutter release down partway while simultaneously pressing the camera's FE lock button. This will lock the focus and exposure readings. The active focusing point, which is linked to the FE lock, flashes red in the viewfinder. When the FE lock button is released, the 380EX emits a pre-flash, which measures the subject's distance and reflectivity. The letters "FEL" (Flash Exposure Lock) appear in the camera's viewfinder for about half a second, and the flash exposure setting is locked. The flash exposure setting is stored for 16 seconds, which should be enough time for you to adjust the composition as you wish. If the shutter is not released within those 16 seconds, the FE lock setting is canceled.

If the subject is too far away for the flash exposure to lock onto

it, the lightning bolt will blink in the viewfinder display. In that situation, move closer to the subject and repeat the procedure.

Setting Custom Function 8, setting 1 lets you link FE lock to a manually selected AF point on either the Elan II or IIE (EOS 50 or 50E), or to the Eye Controlled Focus point on the Elan IIE (EOS 50E).

Note: FE lock cannot be used when the camera is set to Custom Function 4, settings 1 and 2.

Second-Curtain Sync

The 380EX can be used in conjunction with the Elan II/IIE's Custom Function 6, setting 1, which programs the flash for second-curtain flash sync. This feature fires the flash at the end of the exposure (when the second curtain closes) rather than at the beginning (when the first curtain opens). This is necessary to realistically portray a sense of motion when photographing a moving subject. The camera first records a blur, and then the flash fires, freezing the subject at the end of the exposure so that the blur appears to follow the frozen subject. This feature will work only if the Elan II/IIE is set to Shutter-Priority AE, Aperture-Priority AE, or Manual mode with a slow shutter speed. Second-curtain sync is also possible (and recommended) with the Bulb setting.

Speedlite 380EX Specifications

Type: Automatic, direct sync, shoe-mount, electronic flash unit with TTL and E-TTL flash control (E-TTL includes a test pre-flash). Other features include AF assist beam, automatic zoom head, and tiltable flash head for bounce capability.

Camera compatibility: E-TTL automatic flash control and other advanced features (FP flash and FE lock) can be used only with the EOS Elan II/IIE (EOS 50/50E) at the time of this writing. Standard TTL flash control and other flash features can be accessed with any EOS camera.

Guide number: Varies depending on zoom head setting. All guide numbers given are at ISO 100: 24mm, 69 in feet (21 in meters);

28mm, 75.5 in feet (23 in meters); 35mm, 92 in feet (28 in meters); 50mm, 102 in feet (31 in meters); 70mm, 108 in feet (33 in meters); and at 105mm, 125 in feet (38 in meters). The guide number also changes in FP flash mode, depending upon the shutter speed and flash head settings, ranging from 8.5 in feet (2.6 in meters) at 1/4000 second and 24mm to 66.6 in feet (20.3 in meters) at 1/180 second at 105mm.

Battery life and recycle time: Using four AA alkaline batteries, it will produce approximately 260 to 1800 bursts recycling at between 0.1 and 7.5 seconds; 75 to 500 bursts recycling at between 0.1 to 4.5 seconds using AA NiCd rechargeables.

Flash duration: 1.4 milliseconds or less.

Coverage angle: Automatic zoom head covers 24mm, 28mm, 35mm, 50mm, 70mm, and 105mm, matching the angle of coverage to the lens in use.

Flash operating modes: Normal sync, high-speed (FP) sync (with the Elan II/IIE), and test firing.

Flash head settings: A maximum rotation angle of 90° upward, with click stops at 0°, 60°, 75°, and 90°.

Exposure control modes: E-TTL automatic flash (EOS Elan II/IIE [EOS 50/50E] only); FE lock (Elan II/IIE [EOS 50/50E] only), TTL automatic flash (all other EOS camera models).

Flash metering system: E-TTL automatic flash metering with test pre-flash (EOS Elan II/IIE [EOS 50/50E] only); E-TTL automatic flash partial metering with test pre-flash (EOS Elan II/IIE [EOS 50/50E] only); and TTL off-the-film automatic flash metering (all other EOS camera models).

Flash exposure compensation: Automatic flash output reduction for fill flash; activated with cameras that have flash exposure compensation.

Flash coupling range (with a 50mm f/1.4 lens and ISO 100): With

139

normal sync, 2.3 to 73 feet (0.7 to 22 meters); with high-speed sync, 2.3 to 39.3 feet (0.7 to 11.9 meters) at 1/125 second.

Fastest flash sync speed: 1/90 second with the EOS Rebel (1000), EOS Rebel II (1000N), and EOS Rebel X (500); 1/125 second with the EOS 630 (600), 650, 700, 750, 850, EOS RT, EOS 10S (10), EOS Elan (100), and EOS Elan II/IIE (EOS 50/50E)*; 1/200 second with the EOS A2/A2E (5); and 1/250 second with the EOS-1N/1N RS, depending on the camera model in use.

*A sync speed up to 1/4000 second can be used on the EOS Elan II/IIE (EOS 50/50E) when FP flash mode is set.

Flash ready lamp: Lamp (marked PILOT) lights red when flash is fully charged.

AF assist beam: Linked to the camera's central focusing point. In complete darkness it is effective from approximately 2.3 to 33 feet (0.7 to 10 meters).

Power sources: Four size AA alkaline (LR6 or AM-3), NiCd (KR15 or KR51), or lithium (FR6) batteries.

Save-energy function: Automatically active when the flash unit is turned on. The flash unit's power is automatically turned off after 90 seconds of inactivity.

Dimensions (w x h x d): 2-15/16″ x 4-1/2″ x 4-1/10″ (75 mm x 113.5 mm x 103.5 mm).

Weight (without batteries): 9.45 oz. (270 g).

The Speedlite 300EZ

This *Magic Lantern Guide* deals primarily with the top-of-the-line Speedlite 540EZ. However, for those readers who do not need all of the power or extra features of the 540EZ (like a pivoting flash head or a large guide number), the Speedlite 300EZ is a great choice. Its guide number is lower than the 540EZ's—between 72 and 100 in feet (22 and 30 in meters), depending upon the zoom-head setting. And the 300EZ is also smaller in size and weight.

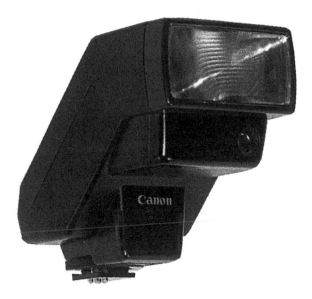

The Speedlite 300EZ is a lightweight, compact flash unit offering A-TTL flash control, auto-zoom capability to four focal lengths, and Rapid Fire Flash Control.

Although its flash head cannot be swiveled or tilted, the 300EZ does include an auto-zoom head, which automatically adjusts for focal lengths of 28mm, 35mm, 50mm, and 70mm, depending on

the lens in use. An illuminated LCD panel displays the focal length setting of the flash head. The zoom head has no manual override.

The 300EZ couples to all EOS cameras for fully automatic control, with either A-TTL or TTL flash control, Rapid Fire Flash System™, and second-curtain sync. When the camera is set in any autoexposure mode, the 300EZ uses A-TTL mode. In this flash mode, the flash unit fires a near-infrared pre-flash in order to determine the flash-to-subject distance and aperture required. TTL flash control is used in Manual exposure mode.

When used with EOS cameras with a flash exposure compensation feature, the intensity of illumination can be varied via the camera's exposure compensation control button. The flash unit has an auxiliary AF assist light, which allows EOS cameras to autofocus in low light.

For those who own a larger, more powerful Speedlite, the 300EZ is useful as a second flash unit when traveling light or for outdoor fill when high power is not necessary. Although it is less convenient than the built-in Speedlites, the 300EZ is substantially more powerful and versatile.

Speedlite 300EZ

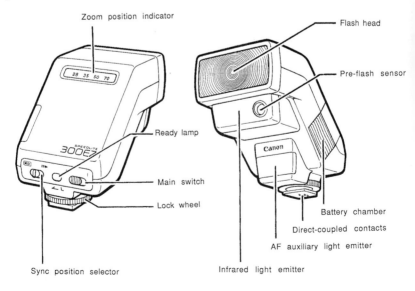

Zoom position indicator

Flash head

Pre-flash sensor

Ready lamp

Main switch

Lock wheel

Battery chamber

Direct-coupled contacts

AF auxiliary light emitter

Sync position selector

Infrared light emitter

Speedlite 300EZ Specifications

Type: Automatic electronic flash unit with A-TTL and TTL flash metering, measuring light off the film surface. Direct coupling, clip-on type unit with auxiliary AF pre-flash, pre-flash for A-TTL, and auto-zoom capability.

Guide number: Varies depending upon zoom head setting. All guide numbers given are at ISO 100: 28mm, 72 in feet (22 in meters); 35mm, 82 in feet (25 in meters); 50mm, 93 in feet (28 in meters); 70mm, 100 in feet (30 in meters).

Recycling time: Using alkalines it will produce 200 to 2000 bursts and recycle in 0.3 to 8 seconds; with NiCds, 65 to 650 bursts recycling in 0.3 to 6 seconds.

Flash duration: 1 millisecond or less.

Coverage angle: Automatic zoom head covers 28mm, 35mm, 50mm, and 70mm, matching angle of coverage to the lens in use.

Flash metering system: A-TTL and TTL automatic flash control by metering light reflected from the film plane.

Flash coupling range (with a 50mm f/1.8 lens and ISO 100): With A-TTL normal-voltage flash, 2.3 to 55.7 feet (0.7 to 17 meters); with A-TTL low-voltage (Rapid Fire) flash, 2.3 to 12.8 feet (0.7 to 3.9 meters) minimum or 39.3 feet (12 meters) maximum.

Fastest flash sync speed: 1/90 second with the EOS Rebel (1000), EOS Rebel II (1000N), and EOS Rebel X (500); 1/125 second with the EOS 630 (600), 650, 700, 750, 850, EOS RT, EOS 10S (10), EOS Elan (100), and EOS Elan II/IIE (EOS 50/50E); 1/200 second with the EOS A2/A2E (5); and 1/250 second with the EOS-1N/1N RS, depending on the camera model in use.

Rapid Fire Flash System: Flash can be operated with partial charge within one second of the main switch being turned on.

Flash ready indicator: Lights green on the back of the flash unit

for Rapid Fire flash; lights red when fully charged. Once it is charged, it can be pressed to test fire the flash.

AF auxiliary light: In low light, the flash unit projects a pattern of red light onto the subject in order to give the autofocus system a target to focus on. In complete darkness it is effective between 3 and 20 feet (0.9 and 6 meters).

Power sources: Four size AA alkaline (LR6 or AM-3) or NiCd (KR15 or KR51) batteries. (Lithium batteries are not compatible.)

Save-energy function: Automatically active when the flash unit is turned on. The power to the flash is turned off automatically after five minutes of non-use.

Warning signals: If the main subject is beyond the range of the flash when the shutter release is partially pressed, the aperture and shutter speed blink in the viewfinder.

Dimensions (w x h x d): 2-5/8″ x 3-1/2″ x 3-15/16″ (66 mm x 89 mm x 100.5 mm).

Weight (without batteries): 7-9/16 oz. (215 g).

The Macro Ring Lite ML-3

Although the Speedlite 540EZ is useful for illuminating moderately close subjects (1.7 feet or 0.5 meter) when the flash head is angled downward, for true macro photography at high magnification of 0.5x or 1x (half-size or life-size reproduction), the Macro Ring Lite ML-3 is required. This ring flash is a "must" for every photographer who specializes in nature or other types of macro photography.

Designed specifically for use with the Canon EF 50mm f/2.5 Compact, EF 100mm f/2.8 Macro, and EF 180mm f/3.5L Macro USM lenses, the ML-3 has a guide number of 36 in feet (11 in meters), which is not particularly high. However you'll be using it to illuminate subjects very near the lens, where its power output will usually be adequate even with apertures as small as f/22.

Here, the EOS A2E (EOS 5) is mounted with an EF 100mm f/2.8 Macro lens and a Macro Ring Lite ML-3. This lens' focal length provides greater camera-to-subject distance in the macro range, a useful feature when shooting with flash.

The control unit of the ML-3 is mounted in the camera's hot shoe, and a coiled cord connects it to the ring-shaped flash unit attached to the front of the EF Macro lens barrel. Canon recommends the use of the camera's Aperture-Priority (Av) or Manual (M) operating modes for full control of the f/stop, and therefore, the depth of field.

The ML-3 contains two curved flash tubes that can be fired at once for perfectly even (shadowless) illumination. Either can be switched off to produce directional lighting for creative shadow effects. Two built-in miniature modeling lamps are included as a focusing aid.

Since the exposure is measured using TTL automatic flash control, the results are usually accurate. The film speed set on the camera is automatically transmitted to the ML-3. And after the exposure has been made, a small lamp lights to confirm that the exposure was correct.

There is no need to make calculations or compensate exposure settings when using filters or extension tubes, which reduce light transmission. However, when the ML-3 flash unit is used with an EOS camera that has a flash exposure compensation control, we recommend setting a minus 1-stop (–1) compensation level as a starting point. This produces more subtle lighting, but still helps to fully saturate colors and add some pleasing highlights.

Getting to Know the Macro Ring Lite ML-3

Because the subject is so close to the camera, high-magnification close-up photography requires the use of macro lenses and an unconventional flash configuration. The Canon Macro Ring Lite ML-3 consists of two parts: the circular head and the control unit, which works with the EOS cameras' TTL automatic flash exposure control system.

Circular Flash Head
The flash unit's ring-like head consists of two halves, each containing a curved flash tube behind a frosted screen, and each can be operated independently. In order to facilitate focusing, the Macro Ring Lite ML-3 also has two miniature modeling lamps. These are useful for previewing the lighting effect that will result.

No special adapters are required to mount it onto Canon's EF 50mm f/2.5 or EF 100mm f/2.8 Macro lenses. The operating switch is located on the back of the flash head, while two levers on the side are used to mount and remove the unit from the lens.

The rotating ring allows the flash tubes to be positioned in any configuration in relation to the subject. We recommend shooting with only one of the two tubes to produce sidelighting on three-dimensional or textured subjects; this will add shadows to prevent the subject from appearing flat.

When mounted to an EF 50mm or 100mm Macro lens, the Macro Ring Lite ML-3 is ideal for close-up and high-magnification macro photography. The ML-3 has two modeling lights, and the ring has two separate flash tubes, which can be controlled independently to produce the desired lighting effect.

ML-3 Control Unit
The control unit slides into the camera's hot shoe and connects to the head using the coiled cable that comes with the set. The control unit has a battery compartment, a modeling (focus assist) light button, a sync port with a button for releasing the cable, a ready lamp, a flash exposure confirmation signal lamp, and the main switch.

Power Options
Four AA-size alkaline or NiCd batteries fit into the control unit and

power the Ring Lite ML-3. Follow the diagram in the battery compartment in order to assure correct polarity; the flash will not operate unless the batteries have been properly loaded. When closing the compartment cover, make sure that it tracks properly in the guides to ensure contact with the batteries. Always replace batteries as a full set of four; do not mix battery types. If the ML-3 will not be used for three weeks or more, the batteries should be removed.

Caution: Some NiCds have terminals that are a different size than those of alkalines, so make sure that they work with the ML-3 before buying them.

Mounting the ML-3 to the Lens
Mounting the unit onto an EF Macro lens is easy. Simply press both release levers and mount the reflector on the lens. If the procedure was successful, the head can be rotated through 360°. Next, attach the flash head's connecting cable to the control unit.

Note: Electrical contact is achieved only once the entire U-shaped portion of the plug disappears. The cable can be removed by pressing the release button while pulling out the plug.

Now slide the control unit into the camera's hot shoe and secure it using the tightening knob. Be sure to insert it correctly (not backwards) so that the contacts line up. The control unit must be fully seated in the hot shoe to ensure positive contact. It is through this connection that the film speed setting and other electronic information is transmitted to the ML-3.

Before taking a picture, turn the camera on and move the main switch on the control unit to "I" (on). When the ready lamp comes on, the Macro Ring Lite ML-3 is ready for operation.

Note: The ML-3 has an energy-saving feature that shuts the flash down after five minutes of non-use to conserve battery power. If the interval timer of a Canon data back is in use, the Macro Ring Lite ML-3 turns itself back on 60 seconds before the shutter is released. This will ensure correct flash exposure.

If the camera's trigger is now pressed lightly, the flash ready symbol (lightning bolt) appears in the viewfinder. You can fire a

test flash by pressing the flash unit's ready lamp after it illuminates, however the metering circuits must not be active. Therefore, take your finger off the camera's shutter release button before firing a test flash. After making sure your aperture is set to deliver the desired depth of field (crucial in close-up photography), take the picture.

Macro Ring Lite ML-3 Specifications

Type: Ring-type flash unit designed for macro photography with Canon EOS cameras. It has two flash tubes that can be operated independently. Operates with Canon cameras' TTL flash metering system. Consists of two parts: the flash head, which is mounted on a Canon EF Macro lens, and the control unit, which slides into the camera's hot shoe.

Guide number: At ISO 100, the ML-3's guide number is 36 in feet (11 in meters).

Battery life and recycle time: When using four AA alkaline (LR6) batteries, the number of flashes produced is between 100 and 1000. NiCd rechargeable batteries can produce 45 to 450 flashes. These values can be attained with new batteries or fully charged NiCds when fired at intervals of 30 seconds.

Flash duration: 1.5 milliseconds or less.

Coverage angle: More than 80° horizontally and vertically.

Flash operating mode: TTL automatic flash metering, test firing.

Exposure metering system: TTL automatic exposure metering with automatic flash termination once the values for a correct exposure have been reached. Automatic fill flash is possible in daylight. Film speed settings are automatically transferred from the EOS camera to the flash.

Flash coupling range: Can be used from 0.8 inches to 13 feet (20 mm to 4 meters) in front of the ring itself at ISO 100.

Fastest flash sync speed: With the EOS Rebel X (500), EOS Rebel (1000), and the EOS Rebel II (1000N): 1/90 second. With the EOS Elan (100), EOS 10S (10), EOS RT, EOS 630 (600), 650, 700, 750, and 850: 1/125 second. With the EOS A2/A2E (5) series: 1/200 second. With EOS 620, EOS-1, and EOS-1N/1N RS: 1/250 second.

Flash ready indicator: The ready light glows red when the flash is ready for use. A green light illuminates for about two seconds after the exposure has been made if adequate flash illumination was produced in TTL automatic flash mode.

Modeling lamp: Pressing the modeling lamp button causes two miniature modeling lamps to light for about 30 seconds to assist in focusing and to preview the approximate lighting effect. The lamps can be shut off by either taking the picture or pressing the modeling lamp button a second time.

Power sources: Four AA alkaline (LR6) or four AA NiCd rechargeable (KR15/51) batteries.

Save-energy function: Automatically active when main switch is turned on. Power is automatically shut off after five minutes of inactivity.

Dimensions (w x h x d): Control unit: 2-15/16" x 2-3/8" x 4-3/16" (74 mm x 60.5 mm x 106.5 mm); reflector head: 4-3/16" x 4-7/8" x 15/16" (106 mm x 123 mm x 24.5 mm).

Weight: The control unit weighs 7.9 oz. (225 g) and the reflector 4.9 oz. (140 g).

Speedlite Accessories

Even with the enormous versatility of the 540EZ and the other Speedlite flash units, there are many accessories on the market that can increase the range of photographic possibilities available to you.

External Power Packs

For shooting action sequences or making numerous exposures in a short period of time, an external battery pack can be connected to the Speedlite 540EZ or 430EZ via accessory cables. The Transistor Pack E with six C-size alkaline batteries or the Canon NiCd Pack TP are best for near-instant recycle and numerous bursts. But both are quite large, heavy, and expensive.

A smaller, lighter alternative is the Canon Compact Battery Pack E, which takes six AA alkaline or NiCd batteries. It provides a noticeable improvement over the four AAs that normally power the 540EZ or 430EZ. Lithium AAs should not be used in the model available at the time of this writing, however.

What follows are specifics on these Canon accessories.

Transistor Pack E with Battery Magazine TP and Connecting Cord E

This power pack takes six C alkalines or NiCds, or the dedicated NiCd Pack TP. When the latter is used, the Battery Magazine TP is not required.

NiCd Pack TP with NiCd Charger TP

Canon developed the NiCd Pack TP specifically for the Transistor Pack E. It provides the fastest possible recycling time but needs 15 hours in the charger to attain a full charge.

Compact Battery Pack E

This small, light, external battery pack takes six AA alkalines or NiCds. Using the Compact Battery Pack E also enables faster flash

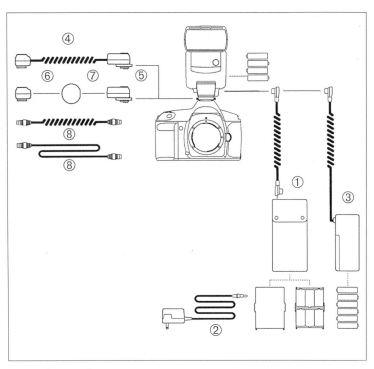

External Power Sources
1. **Transistor Pack E with Battery Magazine TP and Connecting Cord E**
2. **NiCd Pack TP, NiCd Charger TP**
3. **Compact Battery Pack E**

Multiple-Flash Accessories
4. **Off-Camera Shoe Cord 2**
5. **TTL Hot Shoe Adapter 3**
6. **Off-Camera Shoe Adapter**
7. **TTL Distributor**
8. **Connecting Cord 60, Connecting Cord 300**

recycle and more bursts per set than the standard four Speedlite batteries.

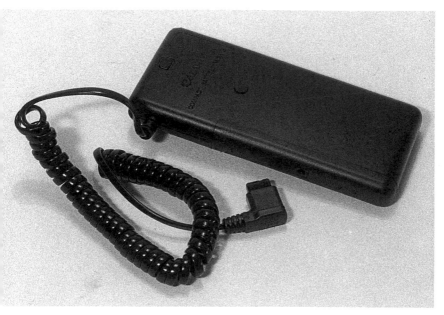

The Compact Battery Pack E offers additional power and faster recycling when attached to the 540EZ or 430EZ.

Accessories for Off-Camera Flash or Multiple-Flash Setups

One advantage of the Canon flash system is that several flash units—up to four—can be used simultaneously while maintaining TTL automatic flash control. The photographer does not have to perform any complex calculations, even in difficult lighting situations. With Canon's Speedlite flash and accessory system, professional effects can be achieved without costly and cumbersome studio strobe systems.

For instance, two or more Speedlite 540EZs create an almost universal flash system that offers optimum lighting control and the ability to eliminate the shadows common with a single light source.

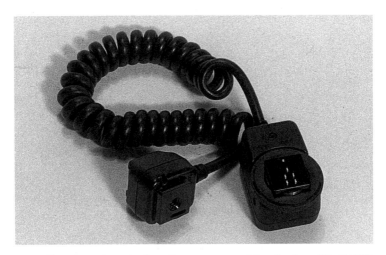

The Off-Camera Shoe Cord 2 allows you to position the Speedlite 540EZ up to 2 feet (60 cm) away from the EOS camera. This creates interesting sidelighting or backlighting effects and prevents the typically flat illumination that results with direct, on-camera flash.

For taking portraits you might try the following setup:

❏ One powerful Speedlite such as the 540EZ mounted on a flash bracket or light stand to bounce light from a silver photo umbrella. This flash unit acts as the main light.

❏ A second Speedlite of lower power or intensity placed near the camera on the opposite side as the main light. The light from this unit should be softer and of lower intensity. (See page 102 for instructions on controlling the flash output of the 540EZ).

❏ A third Speedlite to act as a "hair light." Position it behind the subject or at an oblique angle to add highlights to the hair.

❏ A fourth Speedlite can be used to brighten the backdrop, eliminating any shadows created by the other three flash units.

Canon makes it easy for you to create this system. The following accessories (some or all) are well worth considering if you want to create a more professional look than would be possible with conventional on-camera flash or bounce flash. (For more information on multiple-flash photography, see page 109.)

Off-Camera Shoe Cord 2

This cable allows the photographer to place a single flash unit up to 2 feet (60 cm) away from the EOS camera while maintaining all TTL flash functions. It basically acts as an extension cord—one end attaching to the camera and the other to the flash. With this accessory, the Speedlite can be placed to the side and slightly above the camera, which produces more natural lighting in portraiture and prevents red-eye even in dark conditions. The Off-Camera Shoe Cord 2 is compatible with all EOS cameras except the EOS 630 and the EOS RT.

Of course, the flash unit must be supported, either by mounting it to a bracket or by holding it in your hand. Brackets such as the Stroboframe ProT, RL 2000, or Flash/Umbrella Bracket for light stands (all available from The Saunders Group, address on back cover) are handy for mounting the flash unit securely off-camera, alleviating the need for you to hold the flash in your hand while shooting.

TTL Hot Shoe Adapter 3

This adapter is equipped with two sets of direct-coupled contacts plus a socket for a Connecting Cord 60 or 300. It requires a 3v lithium battery (CR 2025). By mounting this adapter between the camera's hot shoe and the flash unit, a Connecting Cord can be

The TTL Hot Shoe Adapter 3 is mounted between the flash and the camera. It has a port for a Connecting Cord so that an additional flash unit can be added to the system. By using it with the Off-Camera Shoe Adapter (right), a TTL Distributor, and Connecting Cords, you can create a multi-flash setup.

used to add additional Speedlites to the system. Either the Off-Camera Shoe Adapter or the TTL Distributor is also required.

Off-Camera Shoe Adapter

This device is equipped with one set of direct-coupled contacts and a Connecting Cord socket. It has a tripod socket on its base so that it can be mounted onto a light stand. A Speedlite attached to the direct-coupled contacts can be connected to the TTL Hot Shoe Adapter 3 or to the TTL Distributor using a Connecting Cord.

TTL Distributor

This adapter has four sockets for Connecting Cords. One cord must be connected to the TTL Hot Shoe Adapter 3, which sits between the camera's hot shoe and the on-camera Speedlite. Up to three other Speedlites can be connected to Off-Camera Shoe Adapters, creating a multi-flash configuration of up to four units. Such set-ups are almost a necessity for producing pro-caliber results with portraiture and still lifes.

The TTL Distributor makes it possible to use up to four Canon EZ Speedlites at once. Since light from the multiple-flash setup is controlled by the TTL system, no complex calculations are required.

Connecting Cords 60 and 300

You'll need a cable to connect several flash units, and two are available from Canon—one 2 feet (60 cm) and the other 10 feet (3 meters) long. Several cords can be linked to extend the distance from the camera, but the total length should not exceed 30 feet (9 meters) in order to guarantee that the off-camera Speedlites are triggered.

Remote Switch 60T3 and Extension Cord 1000T3

An important accessory when working from a tripod is Canon's 60T3 remote control. It is an electronically controlled cable release and allows you to trip the shutter without creating vibration. The Remote Switch 60T3 electromagnetic cable release can be used with the EOS-1, 1N, 1N RS, A2, and A2E. It can be used with the EOS 620, 630, 650, and RT with the Grip GR-20 attached. For long timed (bulb) exposures, when shooting fireworks or night scenes, for instance, the trigger can be locked. The 1000T3 Extension Cord lets you to extend the distance you are from the camera, allowing you to fire from up to 33 feet (10 meters) away. This is helpful when you require a greater distance for stealth or safety.

Note: Those who do not own the 60T3 or forget to take it along can use the camera's self-timer (if the camera is mounted to a tripod) instead to trip the shutter without creating vibration.

Remote Switch RS-60E3

The Remote Switch RS-60E3 reduces the danger of camera shake during long exposures. It is compatible with the EOS Rebel X, XS, and Elan II/IIE cameras.

Indirect Flash Accessories

Canon does not make all of the accessories that can be handy in flash photography. For example, the flash brackets, light stands, reflector panels, photo umbrellas, and diffusion and bounce accessories described previously are all available from independent suppliers.

LumiQuest, for instance, makes a wide range of lighting accessories useful for achieving a variety of effects. The LumiQuest Pocket Bouncer (easily attached to the Speedlite 540EZ), redirects light from the flash 90° onto a larger white surface, diffusing the light to make the light softer. With TTL flash exposure control, no exposure compensation is required with this or other bounce devices (however shooting distances may be reduced somewhat). Only one stop of light is lost, considerably less than when bouncing flash from a ceiling.

The LumiQuest Pocket Bouncer is useful when a soft lighting effect with minimal light loss is desired.

If you want the flash only to lighten shadows, try the LumiQuest 80/20 bounce accessory. Its reflective panels directs 20% of the light towards the subject and the remaining 80% to the ceiling for indirect lighting. When using a single flash especially, this is useful for adding a catchlight to the eyes, as discussed in an earlier chapter. The amount of light lost depends on the height of the ceiling and its reflectance, but it is slightly less than with 100% bounce flash.

For even softer light, LumiQuest offers an Ultrasoft bouncer. This accessory sends light through a matte diffusion screen (over the flash tube), and then redirects it at an angle of 90°. This creates a very soft lighting effect. Completely shadow-free lighting can be achieved, which can be useful in portraits and still lifes.

If even softer light is required in portraiture or close-ups, try using the LumiQuest Big Bounce. This is similar in design to the Ultrasoft, but softens the light even further by making flash into a

much larger light source for softer illumination. It is reasonably compact. The loss of light is three full stops however, so the Speedlite must be positioned quite close to the subject: perhaps 6.6 feet (2 meters) or less.

Note: If several EZ-series flash units are being used together, a LumiQuest accessory can be mounted on the Speedlite aimed at the backdrop, for moderate illumination of the background.

Studio photographers often use large softboxes, which contain several flash units. Softboxes have a diffuser panel over the opening to produce soft, even illumination. A small softbox from Westcott® or LumiQuest can be attached to a 540EZ Speedlite to produce similar effect—at distances less than 10 feet (3 meters)—in order to simulate a relatively large light source. These small accessories usually attach to the flash unit with Velcro™ strips (LumiQuest) or some form of frame (Westcott).

Note: When considering the many types of softbox accessories available, pick the largest one for portraiture. The smaller models are acceptable for shooting nature in the field, or for small still-life compositions when the off-camera flash can be placed very close to the subject. The closer the flash (with or without a softbox) is to the subject, the larger the light source becomes in relation to the subject, and the softer the lighting effect.

Close-Up and Macro Photography

Exploring the world of the minuscule can be a fascinating photographic experience. Unusual views of common objects are possible, while details not noticed by the naked eye can make striking photographic images. Electronic flash makes taking extreme close-ups easier and even allows you to take high-magnification photos that would be impossible without high-power flash.

The Canon Speedlite system is very flexible in this application as well. A conventional unit like the Speedlite 540EZ is suitable for some close-up photography. In the true macro range—at reproduction ratios of 1:2 or a full 1:1—the Macro Ring Lite ML-3 is an ideal accessory (see the *Macro Ring Lite ML-3* chapter). Both use TTL automatic flash exposure control with EOS cameras, eliminating the need for complex calculations even when accessories are used that reduce the amount of light transmitted through the lens, such as filters or extension tubes, for instance.

Let's consider close-up photography first, in the range of magnification up to 0.25x. Easily achieved with many EF zooms with "macro" designation or prime lenses with accessories, this is also denoted as a reproduction ratio of 1:4 or 1/4 life size. True macro lenses can be used as well, but are not required until higher levels of magnification are desired.

Close-Up Photography with the Speedlite 540EZ

Lighting an object that is very close to the lens with the Speedlite 540EZ would normally not be feasible, as the flash head sits far above the lens axis. The light would illuminate primarily the top of the subject, and, due to parallax error, the lower section would remain in shadow.

Angle the flash head downward by 7° to provide proper flash coverage for subjects located as close as 1.7 feet (0.5 meter). The downward tilt symbol now appears on the 540EZ's LCD panel warning that flash is suitable only for subjects within its flash range (1.7 to 6.6 feet [0.5 to 2 meters]).

The Speedlite 540EZ's flash head was tilted down to its 7° position, allowing for even illumination without light fall-off for this close-up.

Because flash range in close-up photography is not as wide as in conventional photography, the 540EZ's (and 430EZ's) coupling range distance scale is very useful (though it does not function in Program mode). After focusing, press the camera's shutter release button slightly to activate the metering circuits. Now check the coupling range distance scale on the flash unit's LCD panel; the coupling range distance bar lights as a reminder of the flash's range. The bars to the right of the 6.6-foot (2-meter) mark and to the left of the 1.7-foot (0.5-meter) mark will blink as a reminder that the head is set for the close-up position. (Actually, the latter range limit will vary depending upon the film speed and aperture in use.)

If you have focused on a subject that is too close or too far away, all of the coupling range distance bars blink as a warning that the shooting distance is inappropriate. Change the camera's position to ensure that flash exposure will be correct. (For subjects that are closer than 1.7 feet, you can use the 540EZ in combination with the Off-Camera Shoe Cord 2.)

Hint: When shooting close up with the 540EZ, we suggest setting the flash unit's zoom head to the 24mm position regardless of the actual focal length of the lens in use. Using the 18mm wide panel setting is even better!

Camera Operation

When the EOS camera is in Full Auto or a Program mode, both aperture and shutter speed are selected automatically. The resulting depth of field at the typical f/16 or f/22 should be fine at magnifications below 0.25x. In the standard Program mode, you can shift to other aperture-shutter speed combinations, but the system will revert to its own choices after each frame. All flash functions will be fully automatic in the 540EZ's A-TTL mode as long as the subject is within the close-focusing range.

In most cases, Manual exposure mode is the option to choose for complete control over your exposure. However, if fill flash is desired, one option to try is to mount the camera on a tripod and work in Aperture-Priority mode. You select the desired aperture—perhaps f/16 for more depth of field—and the camera sets the corresponding shutter speed. It will probably be quite long, perhaps 1/15 second, hence a tripod should be used. And on windy days, subject blur will be a problem due to the long ambient-light exposure. You may need to switch to a wider aperture for a faster sync speed. Review the section on using flash in Aperture-Priority mode on page 79 for more information.

Hint: If your EOS camera has a depth-of-field preview control (a Custom Function in some cameras) use it to estimate the depth of field at various apertures. When an f/stop holds the entire subject within the zone of sharpness without making the background sharp too, you have found the ideal aperture.

Outdoor Close-Ups with Flash

When shooting outdoors in sunshine, flash serves to lighten deep shadows. On overcast days, flash brings out brilliant colors, so it becomes especially important when gray clouds cast a shadow onto the subject like the petals of a flower. Though these shadows are not readily visible to the eye, pictures taken in such conditions without flash tend to be "muddy" as colors are contaminated and desaturated.

The best close-up subjects are those that have distinct shapes, colors, textures, or structure. If the background is cluttered, try one of the following techniques:

❏ Shade the background so that it will appear dark in the photo. A small, black umbrella can be easily set up on the ground to create shade, but make sure that it is not included in the frame.

❏ Use a piece of black velvet cloth or a sheet of colored construction paper as a backdrop, or paint your own "natural" background; the prop should be supported in some way or held by a friend.

❏ Shoot at fast sync speeds in the camera's Shutter-Priority mode to minimize background exposure. The background will be rendered darker at 1/250 second than at 1/15 second, for example. The longer the shutter speed the more time the ambient light has to register on film.

❏ Set a –1 exposure compensation factor on the EOS camera (if it has this function) to produce a darker background, making background clutter less visible in the photo. Set a +1/2 or +1 flash compensation factor on the 540EZ to keep the subject lit by the flash bright. Some experimentation will be required to produce predictable exposures in the future with this technique.

Close-Up Flash with Multiple 540EZs

Once you have mastered close-up work with a single on-camera 540EZ, consider shooting with more advanced lighting setups. Use an Off-Camera Shoe Cord to extend the Speedlite's position to a remote location, slightly above and to the side of the subject to simulate sunlight, perhaps.

Use the multi-flash accessories to assemble a setup with a 540EZ as the main light source and a less powerful flash unit for fill flash or background lighting. You may want to set the second flash behind the subject or bounce the light off a reflector to give a flower's petals a translucent look, for instance. The entire effect can be significantly altered by changing the position of the two Speedlites and varying their distances to the subject.

A macro flash bracket can also be used to hold one or two Speedlites off-camera. A model such as the Lepp II Dual Flash Macro Bracket, available from The Saunders Group (address on

back cover), creates a "mini-studio" at the end of the lens with the use of two 10-inch (25.4 cm) retractable arms. A Speedlite can be mounted to each arm and individually positioned, providing numerous lighting effects and ratios.

Macro Photography with the Macro Ring Lite ML-3

In true macro photography—with reproduction ratios from 1/2 to full life size on the film—the EZ Speedlites are not always suitable. Because your subject will be extremely close to the front element of the lens (especially with the EF 50mm Macro lens), there is not likely to be adequate space for positioning even an off-camera Speedlite. In that case, you need a flash such as the Macro Ring Lite ML-3 that mounts on the lens.

Refer to the *Macro Ring Lite ML-3* chapter for instructions on mounting and operating the Macro Ring Lite. Take advantage of its modeling light, which aids in focusing and evaluating the image's lighting and composition. The modeling light is especially useful when the camera's depth-of-field preview function is engaged because the viewing screen darkens at small apertures, making it difficult to see the subject without this amenity.

If both flash tubes are activated, perfectly even flash illumination is produced. This is ideal for documentary photography when every detail must be clearly defined and a sense of depth is important. However, a flat, frontal light is not suitable for nature photography, when a "natural" lighting effect is desired for aesthetic reasons. For that situation we recommend activating only one of the tubes. The flash ring rotates so the tube can be positioned where desired: usually to the left or right of the subject for sidelighting. This simulates natural light and produces shadows and pockets of contrast for a very appealing effect. If desired, a reflector panel can be set up on the other side of the subject to bounce a bit of light into the shadow area.

The Macro Ring Lite ML-3 can be combined with up to three other EZ Speedlite flash units using multi-flash accessories to produce even more interesting lighting variations (see the *Accessories* chapter).

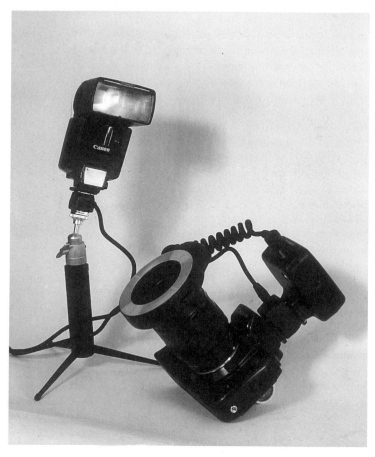

A Canon EOS A2E (EOS 5), a Macro Ring Lite ML-3, and a Speedlite 540EZ make a great combination. The 540EZ was connected to the camera via a TTL Hot Shoe Adapter 3, an Off-Camera Shoe Adapter (which also allows the flash to be mounted on a tripod), and a Connecting Cord.

Depth of Field

In extreme close-up work, depth of field (the zone of apparent sharpness) is very limited. This does not pose much of a problem with flat objects such as stamps, but for three-dimensional objects, a small aperture (f/16, f/22, or f/32) is required to render the entire subject sharply. Although it requires more experience, Manual exposure mode is recommended to achieve complete control over

the exposure. However, Aperture-Priority (Av) mode is an excellent alternative since the f/stop to be used will be the primary consideration in controlling depth of field. In the Av mode the results will probably be more satisfactory, requiring little guesswork.

First, preset the desired aperture on the camera, which will then automatically provide the appropriate shutter speed within the flash sync range of the EOS model in use (between 30 seconds and the camera's top sync speed). Flash exposure control will be TTL in Av mode. Remember that the Macro Ring Lite ML-3's range depends on the aperture selected. It is reduced substantially at small apertures, but this is usually academic with close-up photography.

In extreme close-up work there should be plenty of power available to illuminate the subject in daylight conditions with ISO 100 film. The ML-3's modest guide number of 36 in feet (11 in meters) is adequate for macro photography when the subject is often only inches from the flash tubes. However, you may need to use a slow ISO 25 or ISO 50 film under the most extreme conditions. This will prevent overexposure even at f/22 or f/32 and allow you to select a wider aperture such as f/11 if desired.

Many EOS cameras have a button that can be pressed to preview the depth of field at a given aperture by looking through the viewfinder. (Several EOS models require that you set a Custom Function to utilize this feature.) This feature lets you view the scene at various apertures to assess the resultant zones of apparent sharpness.

Hint: If you stop down to f/16 or f/22 when using the depth-of-field preview feature, the viewfinder screen will be quite dark because you are viewing through a very small aperture, which allows little light to pass through. We suggest stopping down slowly from f/4 to f/5.6, then to f/8, and so on, while keeping the preview button depressed. This will allow your eyes to gradually get accustomed to the darkening view. You can also use the ML-3's modeling lamps to throw more light on the subject while focusing.

Maximizing Image Sharpness
Macro lenses are specifically designed with flat-field optics, offering superior edge-to-edge sharpness over other lens designs. This makes the macro lens ideal for two-dimensional copy work. And

although Canon's EF 50mm f/2.5 Compact Macro and the EF 100mm f/2.8 Macro lens can focus to infinity, they are designed to be sharpest in the close-up range.

For best results in macro photography, use a tripod whenever possible, regardless of the shutter speed selected or whether flash is used. A tripod also facilitates careful composition and depth-of-field preview. Although the brief burst of flash can "freeze" motion, we consider a tripod an essential accessory whenever shooting high-magnification photography with a macro lens. At longer sync speeds, we recommend that you trip the shutter with an electronic Remote Switch accessory. If one is not available, use the camera's self-timer to help prevent camera shake.

Image Composition and Focusing
The Macro Ring Lite ML-3 has two miniature modeling lamps that can be activated to make the task of focusing easier in low light. Press the lamp button on the bottom of the control unit to turn it on. The modeling lamp will illuminate the subject for about 30 seconds, which is usually enough time to set focus. The modeling lamp turns itself off automatically, but this can be done manually too with a touch of the lamp button.

Hint: Focus should always be set before previewing depth of field. Focus on the most important subject element, perhaps the pistil or stamen of a flower or an insect's eye. Autofocus is not suitable in macro photography, as absolutely accurate focus on the most important plane is critical. Do not attempt to focus on the dark screen while the depth-of-field preview button is engaged.

Controlling Exposure
Depress the camera's shutter release button partway to turn the viewfinder displays on. This also activates the light metering circuits. Set the desired aperture and check to make sure that neither the f/stop nor shutter speed display is blinking.

Note: If the viewfinder displays blink there is a serious risk of underexposure. If the shutter speed value is blinking, select a larger aperture (smaller f/number) until the blinking stops, and if the aperture value is blinking, select a longer shutter speed.

Thanks to TTL exposure control, your photos should be nicely exposed. If the subject is within the Macro Ring Lite's automatic range, the green exposure confirmation light will glow for two seconds after the exposure has been made. If it does not light, try shooting again with a wider aperture (such as f/11 instead of f/16) or a faster film (with a higher ISO).

Hint: If you find flash illumination harsh with the ML-3, try covering the tubes with tracing paper to soften the effect. If your EOS camera has a flash exposure compensation feature, check the camera's instruction manual to determine whether it will control an accessory Speedlite. If so, shoot some slide film with a minus compensation setting when working outdoors: –2/3 for the first frame, –1 for the next, and –1-1/3 for the last, for instance (or –1/2, –1, and –1-1/2, depending on the camera in use). This will produce more subtle fill flash. Both techniques reduce intensity, so be sure to check the flash exposure confirmation signal to confirm that the subject was not underexposed.

Lenses for Close-Up and Macro Photography

In order to fill the frame with a large flower (a rose for example), an EF 70-210mm or 75-300mm zoom is an excellent choice. Lenses with a "Macro" designation will focus adequately close to produce a magnification of about 0.25x. The subject will be 1/4 life size on the film frame. Maximum magnification is provided at the longer focal lengths and is lower in the shorter zoom range. (Magnification varies somewhat from lens to lens, so check the specifications.)

The EF 50mm f/2.5 Compact Macro (with the Life Size Converter EF) and the EF 100mm f/2.8 Macro lenses are terrific for anyone who enjoys close-up or true macro photography. These lenses can focus to any distance (up to infinity), so they are useful for numerous other subjects as well. But those who cannot afford (or cannot justify owning) one of these specialized lenses do have other alternatives.

For more information on close-up, macro, and other Canon lenses, refer to the *Magic Lantern Guide to Canon Lenses* by George Lepp and Joe Dickerson.

A macro lens helped isolate this doll from the many that were on display. The Macro Ring Lite ML-3 helped illuminate the doll's face evenly without creating harsh shadows.

Supplementary Close-Up Lenses

The EF telephoto zoom lenses with a "macro" designation will focus adequately close to produce moderate magnification. The minimum focusing distance can be substantially reduced with one of the Canon supplementary close-up (CU-series) lenses. The CU series is affordable and the optics are good to excellent. These lenses come in an economical single-element (500-series) design or a double-element achromatic (250D and 500D-series) design to maximize performance. The 250D CU lenses are available in 52mm and 58mm sizes, and the 500 and 500D CU lenses are available in 52mm, 58mm, 72mm, and 77mm.

With an EF 70-210mm, 75-300mm, or 100-300mm zoom lens, we recommend the CU 500D accessory because of its highly corrected optics. Magnification from about 0.5x to 0.65x is possible, depending on the longest focal length of the zoom lens being used; this brings it well into the true macro range. Image quality remains

very good, particularly in the f/11 to f/16 range of apertures typically used to produce adequate depth of field. This accessory is made with clear glass, producing no loss of light.

Extension Tubes

Canon offers automatic extension tubes (EF 25 and EF 12), which are better suited to single focal length lenses. The extension tube is mounted between the camera and lens, reducing the minimum focusing distance for higher magnification. All automation is maintained, but autofocus operation is less reliable; we advise that you switch to manual focus.

By reducing the minimum focusing distance of a lens, extension tubes increase magnification. For example, the 50mm f/1.8 EF can be converted into a macro lens (with 0.5x magnification ability) by using the EF 25 extension tube. With two or more tubes, magnification can be increased even further.

Other manufacturers also offer longer tubes, but be sure to select one that will maintain your EOS camera's automatic functions.

Note: Extension tubes reduce the amount of light transmitted through the lens. However, in TTL or A-TTL flash exposure control, the system compensates automatically. Ignore suggestions in some books indicating that exposure compensation is required; this is true only with non-TTL flash metering equipment. However, a tripod should generally be used with all close-up shots using extension tubes.

Accessories for Remote Close-Up and Macro Photography

Since the EOS camera is usually mounted on a tripod in close-up or macro photography, the shutter should be tripped remotely to avoid creating vibration. The Remote Switch 60T3 electronic cable release can be used with most EOS models. Consult your Canon dealer for the right switch for your camera. The 1000T3 Extension Cord gives you more length, allowing you to fire the camera from a greater distance, up to 33 feet (10 meters). This is important when shooting bird's nests, a snake, or a scorpion, for example, allowing the photographer to remain a safe distance away.

Other Hints for Close-Up and Macro Photography

Since the zone of apparent sharpness (depth of field) is extremely shallow in macro and close-up photography (the larger the reproduction ratio, the narrower the depth of field) always focus on the most important detail of your subject. With a flower this may be the pistil, with a butterfly or bee, the eyes.

Close-up or macro photography can be practiced with flowers grown at home or purchased from a florist, either indoors or out. Especially on a breezy day, flash is almost essential to "freezing" the to-and-fro sway of your subject. Naturally, other objects such as stamps, details on model trains, or the mechanism of an old watch make ideal subjects as well.

Choose either the Speedlite 540EZ or Macro Ring Lite ML-3 for close-up or macro photography depending on the lens you are using and the degree of magnification desired. At magnifications beyond 1x—as when using a macro lens with a close-up accessory—the use of flash becomes essential to avoid extremely long exposure times.

Photographing People with Flash

The Speedlite 540EZ or several units used simultaneously with an EOS camera can make photography more effective and rewarding. In this chapter we offer some techniques for making more effective pictures of people in controlled conditions. The suggestions provided should be considered only as a starting point for you to gain some familiarity and confidence with the equipment. Then you can go on to experiment further and create a greater variety of advanced effects.

Portrait photos are not necessarily tight "head shots." Very successful portraits show the subject or model at his or her occupation or engaged in a hobby. Some of the techniques provided here can be useful in taking such environmental portraits, but these may call for wide-angle or 50mm lenses so the surroundings can be included. In more conventional portrait photography, lenses in the 85mm to 135mm range are recommended. They produce a pleasing perspective and provide adequate distance between the photographer and the subject. If a soft, out-of-focus background is preferred, a large aperture can be selected using Aperture-Priority or Manual mode. An additional advantage of using a large aperture is that (due to the reproduction gradient of the lens) the image usually becomes somewhat "softer," which often enhances the subject's appearance in a portrait.

Working with the Subject

In order to avoid frustrating your subject (whether shooting indoors or out), set up the equipment in advance, perhaps using a friend as a substitute. During the actual shooting session, the subject should be relaxed. A bit of background music goes a long way towards creating a mood.

During the portrait session, maintain a dialog, suggesting new poses or expressions. Offer positive feedback to keep the person motivated. If you are planning a long session, schedule breaks every 20 minutes for a rest and refreshments.

Flash can improve a picture even when the sun is shining. Here, the sun would have created harsh shadows on the faces of this triumphant soccer team. Fill flash helped illuminate the players' faces so that their expressions are not obscured by deep shadows.

Note: Always focus on the eyes in portraiture (not on the nose, for example). The aperture should be between f/2.8 and f/4 (depending on the lens being used) to render the background as slightly out of focus with shallow depth of field. A 100mm or longer focal length at a wide aperture is most likely to achieve that goal.

Outdoor Portraiture

When shooting portraits outdoors, direct sunlight should be avoided because the model is likely to squint or the sun may cast unsightly shadows onto the subject. Open shade (in an area not lit by direct sunlight) or a bright but cloudy day is ideal for portrait photography.

The pop-up flash head found on most EOS cameras can be used to add a hint of fill lighting on sunny days. However, the guide number of these units is very low and some lenses block the light. Consequently, a Speedlite such as the 540EZ makes sense in such situations as well.

Direct on-camera flash produces surprisingly pleasing results when used for fill-lighting. The Fresnel lens covering the flash tube provides adequate diffusion. However, an Off-Camera Shoe Cord can be used for positioning the Speedlite where desired—slightly above and to the side of the subject perhaps, or on a flash bracket such as those made by Stroboframe. Full TTL flash exposure

To reduce the chance of red-eye, separate the lens and flash axes by mounting the flash to the camera with a bracket. Here, Canon's Speedlite 540EZ is attached to the EOS-1N using the Press-T™ bracket made by Stroboframe®.

Try to photograph family members involved in an activity. Fill flash from the Speedlite 540EZ illuminated the boy and cat in front of a relatively dark background.

control and all Speedlite functions, such as flash exposure compensation, are maintained with the Off-Camera Shoe Cord (except when using the EOS 630 [600] and EOS RT cameras, which are incompatible with the Off-Camera Shoe Cord).

Fill-Flash Techniques

In order to add some illumination and catchlights in the eyes, A-TTL flash control provides the most accurate effect. In Full Auto or any Program mode, the EOS system will automatically reduce flash intensity and provide only fill lighting. Naturally, the camera's Aperture-Priority and Shutter-Priority modes can also be used to similar effect but with less sophisticated TTL flash exposure control.

If you still find the results brighter than you intended (indicating excessive flash intensity), use a minus 1/3 or minus 2/3 flash exposure compensation the next time. This can be set on the

430EZ or on the 540EZ (by pressing the SEL/SET button and then the "–" button as described on page 85). If another Speedlite that does not have a flash exposure compensation control is used (the 300EZ, for instance), flash compensation can be set on the camera instead with the EOS-1N/1N RS, EOS A2/A2E (EOS 5), and EOS Elan II/IIE (EOS 50/50E).

Note: Flash exposure compensation cannot be set in the Full Auto program of most EOS cameras.

We recommend Shutter-Priority mode for full control of the shutter speed, within the sync speed range. Outdoors, a 1/125 second, 1/200 second, or 1/250 second (depending on the EOS model) is usually adequate for fill flash.

Backlighting
We find that backlighting provides a dramatic effect, as the sun produces a halo of light around the model's head from behind. Unfortunately, the face in shadow is barely recognizable. Once again, automatically controlled fill flash is highly desirable, almost essential, as camera and flash work together to produce the right amount of fill for maintaining the backlit effect while keeping the face illuminated for excellent results.

Hint: In extreme backlighting, some underexposure may occur due to the bright light read by the metering system. Try setting a +2/3-stop flash exposure compensation on the 540EZ in a Program mode. After viewing the resulting photos, you can decide on your preferred strategy for future sessions; you may find +1-stop flash exposure compensation—or some other factor—more to your liking. The background exposure can be controlled by setting exposure compensation for ambient light on the camera body. With the EOS-1N and the EOS A2/A2E (5), Custom Functions 14 and 16 (respectively) can be used to disable the camera's automatic flash output reduction feature. This allows flash exposure compensation to be set without the flash being forced into acting as fill flash.

Fast Sync Speeds
A fast sync speed is important in backlit situations to prevent an

excessively bright background. The EOS cameras with top sync speeds of 1/200 second (EOS A2/A2E [5]) and 1/250 second (EOS 620, EOS-1, and EOS-1N/1N RS) offer an advantage for this kind of photography. When ISO 400 films are used in bright conditions, the EOS Elan II/IIE (EOS 50/50E) mounted with a Speedlite 380EX set in FP mode is particularly useful for shooting with faster sync speeds such as 1/500 second.

Hint: Fast sync speeds will also allow you to use wide apertures (such as f/4) to blur a distracting background and create shallow depth of field. This requires a focal length of 135mm and longer as shorter focal lengths produce more depth of field. If you prefer shorter lenses, consider the EF 85mm f/1.2 or the EF 100mm f/2 lens; at the wide maximum aperture depth of field will be limited.

Fill Flash at Slower Sync Speeds

The EOS cameras with a 1/90 second or 1/125 second sync speed can still be used in bright light with films up to ISO 100. However, small apertures such as f/16 will commonly be selected to prevent overexposure in brilliant conditions. (A small aperture allows less light to expose the film.) If you select f/5.6 for example (in the Av mode of the camera, perhaps), overexposure will occur. The aperture symbol in the viewfinder blinks as a warning to set a smaller aperture. If you shoot at this aperture anyway, the subject may be exposed correctly by flash, but the background will be excessively bright.

If the lens' maximum aperture (smallest f/number) blinks in Program mode, overexposure is likely. In this case, switch to a film of lower ISO, if possible. Because few color print films below ISO 100 are available, you may need to use a filter over the lens to reduce the transmission of light. Most people own a polarizer, which will reduce the amount of light reaching the film by about 1.5 to 2 stops, depending on the model.

Neutral Density Filters

If the above solutions are still not adequate—for instance, if you want to use a very wide aperture in bright light at 1/90 second or 1/125 second sync—try a neutral density (ND) filter. Because it is gray, it produces no color cast. ND filters are available in various strengths—the higher the ND number, the darker the filter glass.

This train in the York Railway Museum was backlit. The Speedlite 540EZ was used to provide front fill lighting in order to bring out the detail in the engineer's room.

Even with EOS cameras with fast sync speeds, an ND filter can be useful when using a portrait lens at a wide maximum aperture of f/1.2 to f/2, especially in bright light or with ISO 100 to 200 film. These conditions can avoid the necessity of stopping down to a smaller aperture (larger f/number) with too much depth of field. For portraits, shallow depth of field (a narrow range of apparent sharpness) is usually preferable to defocus or obscure the background.

Controlling Background Exposure

The photographer has very precise control over the brightness of the background when using the Speedlite 540EZ for fill lighting. Outdoors, the background is illuminated by natural light, while the subject in the foreground is lit by the flash. As a rule of thumb, the longer the shutter (sync) speed, the brighter the background will appear.

In Shutter-Priority (Tv) mode, the naturally lit background can be rendered as lighter or darker by adjusting the shutter speed. In Aperture-Priority (Av) mode, a long shutter (sync) speed is selected by the camera when you set a small aperture such as f/16. At that setting, the background will be rendered quite brightly even in late evening or at night when shooting a subject against a city sky-line, for instance. A tripod will be required in this situation to prevent image blur.

Or, for the sake of simplicity, if the camera features an exposure compensation control, it can be used to control background exposure when in Program mode. A plus (+) setting will produce a brighter background, while a minus (–) setting will provide the opposite effect. The flash exposure compensation control of the 540EZ or 430EZ can then be used to adjust the brightness of the foreground subject.

For example, in Program mode, set a –1 compensation on the camera and +1 on the 540EZ. The subject will be rendered quite brightly against a dark background. If you do the opposite, the opposite effect will result. Use slide film for experimenting to avoid the arbitrary exposure "correction" steps that might be made by a lab in the printmaking process.

Note: Fill flash is often useful in nature photography as well as for portraits. The atmosphere of the image can vary substantially, depending on the brightness of the background, as when shooting in the deep shade of a forest, for example. A dark background without detail may not be the most effective for every situation, so a longer sync speed would be required.

Shooting Indoors

Indirect Flash

Indoors, bouncing flash from the ceiling can produce distinct or soft shadows around the eyes, depending on the distance the flash is from the subject (the farther away, the better). A second smaller or more distant flash should be used to create fill lighting for a professional look. Or take a tip from some portrait photographers and ask the model to hold a reflector—perhaps a sheet of cardboard covered with wrinkled aluminum foil. This will bounce

some light into his or her face, acting as fill. Naturally, the reflector should be outside the image area.

When the flash is aimed at the ceiling, the loss of light, depending on the distance involved, can be considerable. Since a large aperture (small f/number) is generally used in portraiture to separate the subject from an out-of-focus background, this is not usually a problem in a home with ceilings that are roughly 9 feet (2.7 meters) high. The high guide number of the Speedlite 540EZ helps prevent underexposure in typical situations. Check the flash exposure confirmation indicator after the picture is taken. If the distances involved are too great, switch to a film with a higher ISO, perhaps 200 or 400 instead of 100.

Instead of using the ceiling as a reflector, try bouncing the light from a side wall instead. Ask a friend to hold a large white reflector on the other side of the subject. We prefer the rugged California Sunbounce panel outdoors (available from The Saunders Group, address on back cover), but a sheet of white Bristol board, foam core, or Styrofoam™ board (from a hardware store) will do indoors. Some light will bounce back from this second reflective surface to fill in shadows.

Using several flash units is often a good idea, particularly in portraiture. Colored cellophane or gels—available form Bogen, Lee, Rosco, and other manufacturers—can be placed in front of the Speedlite aimed at the background to produce creative color effects.

Seamless Backgrounds
Those who are not satisfied with the background available in their living room can acquire specialized backdrops in almost any color or pattern. These rolls of paper can be obtained at professional photo stores or through some mail order catalogs (advertised in photo magazines). Choosing the right background for portraiture is very important; it should not distract the viewer from the primary subject.

Sidelighting
Until now, we have discussed the use of soft lighting, but this does not always produce interesting pictures. Hard sidelighting can be much more expressive, on occasion. To create this effect, connect the Speedlite 540EZ without any diffusion accessory to the

camera with the Off-Camera Shoe Cord 2. If this accessory is too short (2 feet/60 cm) for your needs, you'll need to try the following alternative:

❏ Attach a TTL Hot Shoe Adapter 3 to the camera's hot shoe.
❏ Attach a Connecting Cord 60 or 300 to the adapter. (Connecting Cord 300 is recommended as it is 9.8 feet/3 meters long. The Connecting Cord 60 is only 2 feet/60cm long.)
❏ Attach an Off-Camera Shoe Adapter to the far end of the connecting cord.
❏ Mount the remote Speedlite on the adapter.

Now you can experiment with various sidelighting effects, depending on the location of the Speedlite in relation to the subject. TTL flash metering is maintained for good exposures. This technique is suitable, especially when shooting portraits of men or women whose faces are etched with lines, to emphasize character for a more dramatic portrait. To avoid extremely hard shadows, use a white reflector on the far side of the subject to add some fill light into the shaded areas.

Two Off-Camera Speedlites
A second flash unit can be used to brighten the background when desired. This time you'll be working with an off-camera Speedlite, which can be aimed anywhere, plus a second off-camera Speedlite aimed at the background. The setup is similar to that described in the section above, but requires additional accessories.

❏ A TTL Hot Shoe Adapter 3 is attached to the EOS camera's hot shoe.
❏ A Connecting Cord 60 or 300 leads from the adapter to a TTL Distributor.
❏ Another connecting cord leads to an Off-Camera Shoe Adapter; one Speedlite is mounted here.
❏ A third connecting cord leads from the distributor to an Off-Camera Shoe Adapter with a second Speedlite attached.

With this setup, TTL flash metering is maintained. The Speedlite used for lighting the background can be mounted onto a tripod for the sake of convenience as the Off-Camera Shoe Adapter

accessory has a tripod mounting socket. The "main" Speedlite can be placed wherever desired: handheld, attached to a flash bracket accessory, or mounted on another tripod or inexpensive "light stand" available from photo retailers. Use reflectors to produce even lighting or colored gels over the background light to create other effects.

Multi-Flash Exposure Control

In multiple-flash setups, flash exposure compensation does not operate if it is set on a Speedlite 540EZ or 430EZ. If desired, such compensation must be set on the EOS camera—this is feasible only with the EOS-1N/1N RS, EOS-A2/A2E (EOS 5), and EOS Elan II/IIE (EOS 50/50E) models. Both Speedlites are then compensated equally (reduced or increased flash exposure). Consequently, this strategy is not useful for varying the brightness of the background light only. There are other techniques for decreasing the light produced by one or more of the Speedlites independently. The simplest method is to move the background flash unit farther away or cover its head with tracing paper, a colored gel, diffusion accessory, etc. to reduce light output. Or you can set the zoom head to a wide-angle position.

If a Speedlite 540EZ or 430EZ is used to light the background, it can also be set to produce a darker exposure by switching it to "M" (Manual flash mode). However, be aware that this will cause all connected Speedlites to be switched to Manual flash mode as well. With the +/– button, set reduced flash output—perhaps 1/2 as a starting point (see "Flash with Manual Exposure Mode" on page 83). The background will now be less prominent due to reduced brightness.

For Manual flash operation, focus the camera on the background and press the shutter release button halfway. The coupling range distance scale on the LCD panel of the Speedlite 540EZ and 430EZ indicates how far from the background the flash unit should be located. Set up this flash unit (mounted on a tripod) at the correct distance. The EOS camera's TTL flash metering system will take care of exposing the main subject correctly. Follow the camera's ambient light metering suggestions for exposing the background correctly. Now, refocus on the subject and take the picture.

Three Off-Camera Speedlites

Some portraits demand that the hair shine brightly with backlight. This is easily accomplished with the Speedlite 540EZ system. Simply add a third unit to the two-Speedlite setup just described—another Speedlite 540EZ or another EZ model. You'll also need another Connecting Cord (for hooking up to the TTL Distributor) and an Off-Camera Shoe Adapter, of course.

This third Speedlite would also be mounted on a tripod or light stand for convenience, positioned so it produces a crown of light around the model's hair. Carefully check the viewfinder image to ensure that the remote equipment is not included in the picture. Trip the camera's shutter, and a perfect photo should result as all three units are controlled by the TTL exposure metering system.

Hint: Unlike studio flash systems, the Speedlites (except the Macro Ring Lite ML-3) do not offer a modeling light to help preview the lighting effect. Always take several pictures when using such complicated setups. Change the lighting angles occasionally to vary the effect. Even slight changes in the location of the Speedlites can substantially affect the results. After all the time and effort invested, this is not the place to try saving on film.

Flash Filtration for Portraits

Some photographers (and subjects) appreciate the effect created by one of the many soft-focus filters such as those manufactured by Cokin®, or the Canon Soft Focus EF lens, discussed in the *Magic Lantern Guides* to Canon cameras and lenses. However, flash light can be filtered too, a technique used particularly in two common situations.

Filtering for Fluorescent Light

When shooting under fluorescent light, a green cast will occur in areas not illuminated entirely by flash—as in a wide-angle environmental portrait in an office situation, for example. A magenta filter on the lens is useful in existing-light photography to counter the green bias of such lighting. However, when flash is used this is not the most suitable solution because some of the scene will still be illuminated primarily by the overhead lighting.

Unless multiple high-power Speedlites (or commercial flash systems) are used, the most successful technique we have found works as follows:

❏ Cover the flash tube of the Speedlite with a CC30G (green) gel from Bogen, Lee, Rosco, or another manufacturer. This will produce a green cast similar to that of the overhead lights, balancing the color of the two light sources.

❏ Attach a CC30M (color correcting magenta filter with a factor of 30) or an FL-D (magenta) filter over the lens to counter the green cast.

Note: The above strategy is best employed when flash will provide only fill lighting, with the artificial illumination being an important factor in the image. However, in tight portraits where the subject is lit by flash, no filtration is required on the Speedlite or lens. If working with color negative (print) film, any slight green cast can be eliminated in the printmaking process. If a mass production lab cannot produce acceptable results, consider the services of a custom lab; check the telephone directory under "Film" or "Photo" in any city.

Flash Filtration Outdoors
When shooting portraiture outdoors, use daylight film and try shooting around sunrise or sunset when the ambient light is very "warm." This lighting is very pleasing in most situations.

But let's say you do want to add fill flash, perhaps to shoot a model against an evening sky, just as the sun is setting. The ambient light of the background will be quite warm, consisting of orange hues. The Speedlite however, will produce "cooler" white light. If you want to match the color of the light sources, an orange filter over the flash tube will be required. A 10CC to 30CC color correcting gel should produce the desired effect. The higher the CC number, the deeper the orange shade of the gel. Ask your photo retailer to check the Bogen, Lee, Rosco, or other manufacturer's catalog for the right filter for your flash in such situations.

With TTL or A-TTL flash exposure control, no calculations are required and the results should be "correct." However, you cannot always predict the effect accurately, so try bracketing flash exposures especially if you are shooting slide film. Shoot several

frames, each at a different flash exposure compensation level. Then shoot several more, varying the ambient light exposure instead.

Glamour and Nude Photography

Choosing Equipment

Although commercial photographers generally shoot glamour and nude photos in larger formats, 35mm equipment is fine for non-professionals. Thanks to modern film technology, the difference is barely visible in an 8" x 10" enlargement. Color negative or slide films of ISO 50 to 100 are recommended. They offer practically no visible grain and excellent sharpness.

A 50mm lens (or a zoom lens that includes this focal length) is our first choice for glamour photos, unless you are shooting tight close-ups. It offers a "natural" perspective because it is closest to what the human eye perceives. If there is enough room, you can also use a portrait focal length (between 70mm and 105mm). Wide-angles are not the best option unless you want to create certain effects by emphasizing the foreground or various parts of the body.

Glamour Lighting

Direct flash is not the best choice for glamour or nude photography. The softer the lighting, the better the models will look. Hard shadows should be avoided. While the commercial photographers use studio flash systems, excellent results are possible with an EOS camera and several Speedlite 540EZs (or other Speedlite models).

Three flash units can be used to create perfectly lit photos. Always make sure that your main light source is not overpowered by the secondary units. If the main light is on-camera, use indirect flash against the ceiling or use a bounce accessory, such as one from LumiQuest, for soft illumination that flatters the model.

The two other EZ units are used to light the background and hair. The flashes are connected as described in the "Multiple-Flash Photography" section on page 109. The exposure is controlled automatically via TTL metering, so you don't need to worry about complex calculations. Should shadows still pose a problem, use large reflector panels such as the California Sunbounce or large sheets of Styrofoam or spray-painted cardboard.

To illuminate a subject with flash and retain a black background, use a dark, non-reflective backdrop. Position the model as far away from the backdrop as possible to prevent the background from being illuminated by light from the flash. Photo by Bob Shell.

Create a Relaxed Atmosphere for Your Model

Always explain to your model—whether a professional or a friend—what and how you will be shooting and exactly when you are starting. The better the communication between model and photographer, the more successful the shoot will be.

The model's expression is very important. At first, he or she may be unsure and tense. Also, setting up a shot can be very time-consuming and can be taxing on the model. Take some pictures anyway, maintaining dialog until you and the model become comfortable with one another. Never try to save film in these situations. The slightest change in expression or position can produce a completely different image. Go ahead and "sacrifice" some film and pick the best shots later.

Select props that suit the model and create a mood. They should not detract from the model but rather add atmosphere to the image.

Using flash to supplement the ambient light increases the contrast and enhances details. Photo: Bob Shell.

The background—much like the props—should be kept simple so that it too does not detract from the model.

Try experimenting with filters to make the light appear warmer and more flattering to the model. Star filters or soft-focus attachments can also be used for nice effects in glamour photography.

Shooting Still Lifes

Any everyday item by itself or in combination with other common "props" is an ideal subject for a still-life photo. With a creative mind and some imagination, you can make interesting photos anywhere and at any time. Lighting using one or several Speedlite 540EZs (or other Speedlite EZ models) can be uncomplicated with TTL flash exposure control.

One does not need a studio for this kind of work—a living room will do just as well. Still-life photography offers an almost infinite variety of subjects and can be done any time of day or night with

The spinning blades of this Christmas decoration were frozen by the burst of light from a Speedlite 540EZ. Fill flash did not overpower the light from the candles, and the desired atmosphere was maintained.

flash. In inclement weather especially, this can provide an opportunity for refining one's photographic skills.

Exert Full Control

Unlike with portraits, the photographer has full control with still lifes. The subject is never bored or uncooperative! Lighting, subject, color, filtration, choice of focal length, subject distance, and magnification ratio are all completely up to the photographer. Nothing is prescribed; the more "rules" that can be broken, the more interesting the still life can appear in the image.

We will provide a few tips as a starting point for creating effective still-life compositions. After a few sessions, break away from these with some creative experimentation. The dictionary definition of still life is "a display of lifeless objects in an artistic manner," and art requires an interpretive approach.

Selecting Props

A still life may be an arrangement of flowers, memorabilia (like an old photo and grandfather's pocket watch), foods, etc. The subject is often most interesting when several props that are appropriate to the theme are carefully arranged. They may include everyday items such as small tools or specialized aids such as artificial ice cubes or snow, ordinary water in a spray bottle to create "dew," and so on.

Controlling Lighting

Amateur photographers seldom have enough time during the day to attempt this kind of photography, so it is often done in the evening with artificial (flash) lighting. If only one Speedlite is to be used, the highly versatile 540EZ is most appropriate as it offers the widest range of options. Flash also has an advantage over natural light. It is always available in the same quality and is completely controllable. Daylight changes in color temperature and intensity depending on the time of day and the weather. As such, it is not ideal for controlled, still-life photography.

Some photographers use incandescent photo flood lamps, but these are not as useful as electronic flash. The lamps get very hot and can wilt flowers, melt frozen subjects, or even damage

delicate materials. In addition, their color temperature requires the use of tungsten-balanced films or color-correcting filters, while flash can be used with any conventional film type.

Emphasize Textures

Sidelighting can emphasize texture by creating pockets of contrast, which produces a tactile visual quality in a photo. To create sidelighting, connect the Speedlite 540EZ to an EOS camera with the remote accessories described earlier. Place the Speedlite either to the left or right of the subject. If you do not want the shadows on the far side to be completely dark, use a reflector to fill the shadows in a little. The least expensive accessory is a piece of white construction paper or crumpled aluminum foil attached to a sheet of cardboard. White is ideal for lightening the shadows so that a trace of texture remains visible.

For soft, indirect illumination, bounce the flash light from a wall, ceiling, or reflector. The latter can be propped up on a tripod or held by another person. The accessories mentioned on pages 157 to 159 can be used as well.

Creative Filtration

Using filters in still-life photography is common. With color film, a sepia (light-brown) filter adds an "old fashioned" look while an 81B (amber) filter adds a warm glow. Filters can be placed in front of the lens or flash, or both. Suitable accessories for flash can be found at a professional photo retailer or at home: colored cellophane wrapping paper, for example.

If several Speedlite 540EZs are used, you could leave the main flash unfiltered and you could fit each of the additional Speedlites with different filters. There is absolutely no limit to the amount of experimentation and creativity that is possible. Film is still the least expensive tool of the serious photographic hobbyist (when calculated per image), but a missed shot is hard to repeat—even in still-life photography.

Background and Composition

The background is also important in a still-life image. Place an old pocket watch on a mahogany table (or similar artificial surface) and add other items from the era such as a pair of glasses and an old leather-bound book, for example. Photo and art supply

stores sell a wide variety of backdrops that can be used for such applications.

The most important component of a successful image is composition. Although there are no rigid rules in this area, as a starting point, consider the Rule of Thirds: the edge of the primary element in a still life should be located at the top or bottom third of the image area (or at the left or right third). Another rule divides the area into fifths rather than thirds to achieve successful results. But remember, some very interesting images can be created when one consciously ignores the traditional rules of composition.

Techniques for Still-Life Photography

When taking still lifes, we recommend the following guidelines:

❏ Still lifes should be illuminated by a main light source. This may be direct flash illumination, soft indirect flash illumination, or light bounced from an accessory. Sidelight coming from slightly above the subject, like sunlight, or even backlight can also be used as the main source of light. Most still lifes benefit from the main light entering at an angle of 30° to 45° from above (multi-flash accessories and connector cables are required—see the *Accessories* chapter). To avoid harsh shadows, light-reflective surfaces can be used around the subject. The main flash should always be the brightest light source.

❏ Sidelighting is the best way to give objects in a still-life composition a third dimension—to make them look dynamic in an image with shadows, textures, and contrast.

❏ To prevent blur from camera shake even with flash (and for highly precise composition), use a tripod. This has another advantage: you can take time to precisely compose the image, making changes in very small increments.

❏ The objects in a still life should be arranged so that they do not overlap. A camera positioned diagonally above the subject is often helpful.

❏ As with photography in general, the image should have a theme. A series of photographs can then be made, varying the elements that are included or their placement in subsequent frames.

Magic Lantern Guides

....take you beyond the camera's instruction manual.

The world's most popular camera guides; available for most popular cameras.

From Hove Books

Canon Compendium

Written by Bob Shell, editor of *Shutterbug Magazine* and authority on the Canon system. This superbly-illustrated guide features 230 photos of Canon equipment, including early rangefinder cameras, lenses of various generations, etc. It also features a guide to the complete EOS system with information on equipment compatibility, detailed equipment charts and a comprehensive index. Hardbound. 200 pages.